99
Portrait
Photo
Ideas

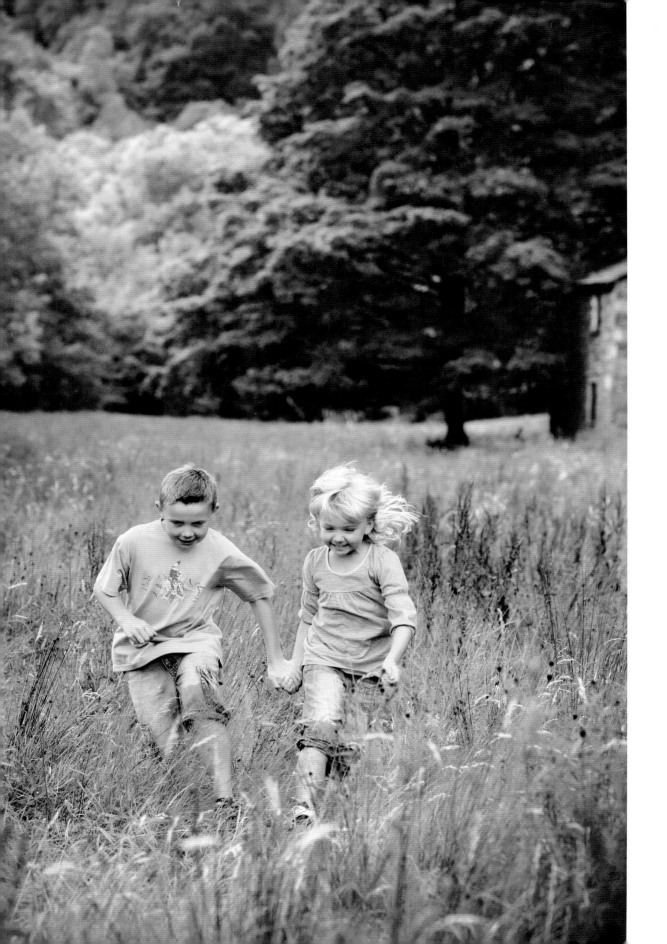

99 Portrait Photo Ideas

apb
angelapatchellbooks

Published by
Angela Patchell Books Ltd
www.angelapatchellbooks.com

Registered address
36 Victoria Road, Dartmouth
Devon, TQ6 9SB, UK

Contact sales and editorial
sales@angelapatchellbooks.com
angie@angelapatchellbooks.com

ISBN : 978-1-906245-01-6

Book design by Toby Matthews, toby.matthews@ntlworld.com
Book concept by Angela Patchell

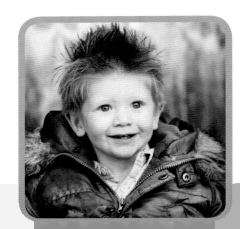
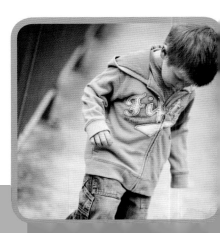

Contents

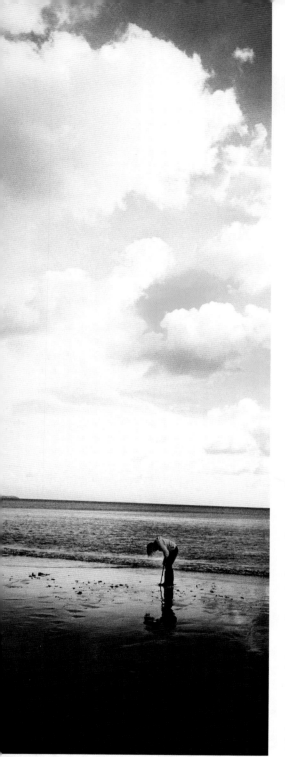

Be Inspired!

Think about photography differently! Forget about cameras and concentrate more on what's around you. The camera is actually the last thing you need to take a photo – literally! The moment you decide to press the shutter is crucial, but it's everything else you do before you press it that makes it a great photo.

If you can relate to people then you can take great photos of them. No amount of equipment will make your pictures better if you can't do that.

I often tell people they would make a great photographer and they say 'how do you know, when you haven't even seen one of my photos?' My reply is always 'I can tell by listening to you, and by looking at you; what you're wearing and the kind of person you are.' Anyone can learn how to use a camera – it's being inspired and knowing what you want to photograph that is important.

The fact you've picked up this book tells me you can do it, because I've designed it deliberately to attract creative people!

» *Do you often see something and wish you had your camera with you?*
» *Do you stop and stare at a beautiful landscape which takes your breath away?*
» *Do you want to capture the way children laugh and play?*
That is inspiration.

» *Do you want to make something out of all those shells you find on a beach?*
» *Do you want to do more with all those photos you take?*
» *Do you find you feel up one day and down the next?*
That's creativity.

Creative people can't stay upbeat all the time! We get so easily inspired by the simplest of things, and so easily bored when we're

not inspired! Understanding this is the key to fulfilling your creativity.

» *Do you love taking photos and enjoy feeling inspired and creative?*
» *Do you often find yourself in your own little world and forget everything else that is going on around you, except for what you are shooting?*
That's passion.

I have always been passionate about photographing people. Nothing excites me more than someone seeing a picture of themselves that they love! Almost every person I photograph tells me they have never had a good photo taken of them and to me this is a red rag to a bull! Something takes over in me, and I am determined to show them that they can look beautiful in a photograph, and that these will be the best pictures they have ever had taken of themselves.

I first started taking pictures because I couldn't get a good picture of myself! Nobody seemed to understand how it felt to see horrible pictures of yourself time and time again – it's no wonder so many women feel so bad about themselves! But I knew that with the right lighting, and attention to detail **ANYONE** can look great in a photograph! Most people just want to look how they feel; it's about understanding that, finding out what they want and knowing how to achieve it.

I started photographing people in a studio with big softboxes on my lights, but I soon became bored with it! I wanted to photograph people outside because the backgrounds were so much more interesting and unpredictable, and people were much more relaxed and natural outdoors. I couldn't find anyone to teach me how to do this so I just went out and made it up myself! I worked out how to recreate that beautiful 'soft box' light by experimenting and thinking outside the box, and I'm still using those techniques today, just with different backgrounds and different fashions.

» Photographing people is 90% psychology and 10% technology

By experimenting, and learning from experience (both good and bad!), I gained the confidence to believe in myself and what I do. So many of us aren't using our passion and creativity because we don't have the confidence.

So as you read this book, keep an open mind and allow yourself to believe you can do it!

Confidence fuels creativity. It gives you the motivation to experiment, and the ability to laugh if something doesn't work out how you wanted it to! Photography is something that most people enjoy, and this book will teach you that you can do anything you like when you're taking a photo – there are no rules – only inspiration. You have the choice to do what you like with that inspiration and hopefully with a few simple techniques you can gain the confidence to focus on your passion and develop your own style and creativity.

Enjoy the experience – have fun!

1 GETTING STARTED IN 6 EASY STAGES

1 **Shooting**

2 **Backgrounds**

3 **Lighting**

4 **Composing**

5 **Directing**

6 **Digital Tips**

» Cameras are so well designed these days, that they really are very simple, provided you just stick to a couple of settings. If you ever want to change it later, then you can, but to begin with **Keep it simple!**

» **Try to think of your camera as the least important thing you need to take a picture!**

ANNABEL'S TIPS

In my opinion, the most important aspects of portrait photography are:

 Rapport with your subjects

 Light

 Backgrounds

4 *Equipment*

In that order!

For many years, photography has been a very technical subject – but it really doesn't have to be that way. Digital photography has made everything so much easier. Stop worrying about the technical side – you don't need to know many things to be able to take great pictures. It's far more important to be able to relate to your subject, and be relaxed about shooting. If you are constantly worrying about which F stop to set your camera on, and which dial does what, you will lose all your confidence and it will make it so much harder!

Once you've learned the simple techniques in this book, you will be able to concentrate on your subject, light and backgrounds and have lots of fun taking pictures without getting weighed down with too much technicality!

SHOOTING

10

What equipment do you need?

It depends on what you want to do!

If you want to keep a camera handy at all times to capture your kids and holiday moments spontaneously – then you may like to use a simple digital compact camera.

WHY?

» You can keep it in your pocket or your handbag!
» It's easy and quick to use.
» You are more likely to take pictures because you are not carrying lots of equipment with you.

If you want to improve your photography and create more interesting pictures, then you may like to use a SLR digital camera.

WHY?

» You can change the lenses for different effects
» You have more control over your lighting
» You look more professional!

I currently use: Canon Powershot A710 IS
digital compact
Canon 1Ds 111 or Canon 5D
Canon 70-200 IS Zoom lens
Canon 24-70 IS Zoom lens

For the purposes of this book, I am assuming you are learning how to use your SLR camera more effectively, but always take your compact with you just in case, and many of the tips in this books are still relevant whatever camera you use.

» How many settings do you use on your washing machine? My guess is 2 at the most! I only ever use quick-wash or slightly longer-wash!

» Your camera is like your washing machine. Set it on AUTO, and let it do it's job. Learn to use it in the right light – and you can't go wrong – **trust me!**

All You Need To Know About Your Camera...

Understanding Aperture and Shutter Speed

> The great news is you don't **NEED** to understand about apertures and shutter speeds!

If you follow the simple instructions given in this chapter, using your camera will become second nature, and you can concentrate on what you enjoy – taking photos! You won't have to make any decisions about your camera, and you'll learn to concentrate on the people in front of you.

Not many people understand how their car engine works – but most of us can manage to drive a car. Do you remember how difficult it seemed when you were learning to drive? And how easy is it now? You don't even think about the car now – just about where you're going!!

When using your camera becomes as simple as driving your car, you can add as many new techniques as you like. But for now, just stick to

the simple way! In fact I've pretty much stuck to this method for 20 years and it hasn't done me any harm!

For those of you who are terrified of the technical side – look away now! You **DO NOT** need to know this bit – it's just here for the people who really want to know why. It will make much more sense when you get to the end of the book!

Aperture

Once upon a time someone invented all these little numbers just to confuse us! All you need to know is that if your camera is set around F4 or 5.6, the background of your images will be more out of focus, than if it is set around F16 or 32.

So if you want to do landscapes and want everything in focus, use the higher numbers, but for portraits where you want the background out of focus use the lower numbers. **THINK** less in focus – lower the number. But don't worry – your camera is going to do all this for you!

EXPOSURE
Apertures

At F11 the background is quite clear and shows that Polly is sitting in front of a shop with bottles in the window. Using a wider aperture of F5.6 throws the background more out of focus placing more emphasis on the subject. At F2.8 this is even more apparent.

EXPOSURE
Shutter Speeds

15 30 60 125 250 500 1000 2000 4000 8000

Slower
Movement More Blurred

Faster
Less Blurred

The slower the shutter speed, the more blurred the image will be if the child is moving, but this can be very effective in some situations.

The faster the shutter speed the less blurred the image will be, but sometimes when the light is poor, it is not possible to get a fast shutter speed, and you need to make sure the child is keeping still if you want a sharp image.

Shutter Speed

These numbers represent how long your shutter is open for (i.e. 1/125 of a second). The longer your shutter is open for (15th/30th of a second) the more chance you have of blurring the image. The quicker the shutter is open for (125th–8000th of a second) the less chance you have of blurring the image.

TIP – **Once you've got your camera set up (see next page) it will sort the shutter speed out for you and you won't need to worry about it!**

›› Keep the "quick set up guide" you get with your new camera but **THROW THE MANUAL AWAY**, it'll only confuse you!

How to Set-up your Camera

Setting up your camera to make it easy to take great portraits needn't be complicated. Follow these simple instructions and you will be well on your way to taking that fabulous picture.

TIP – **Before starting you may need to refer to your "Quick set-up guide" as each camera may vary slightly.**

- **Set your camera mode to Av**
- **Set the aperture to 5.6**
- **Set the ISO on 400**
- **Set the camera to "one shot"**
- **Set the white balance to auto (AWB)**

Exposure

Now find the exposure setting which has 3 different settings like this:

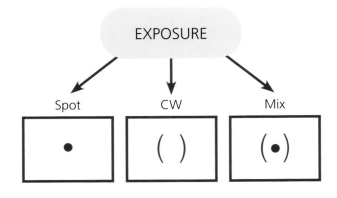

Set your camera to (•)

Focusing

Set your focusing to just ONE RED SQUARE in the middle of the viewfinder

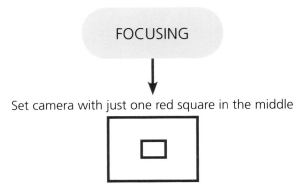

How to Create the Correct Exposure

Once you have set your camera as shown practise the following:

1 Compose your picture, then move your camera so the red square is over the person's face.

2 Hold down your shutter button half way (this will freeze both the exposure and the focus).

3 With your finger still holding the shutter half down, move your camera to the original composition.

The camera will keep the exposure and focus and this will ensure that the face is correctly exposed, and it doesn't matter if the rest of the picture is washed out – it will only make it look more interesting!

PRACTISE!
PRACTISE!
PRACTISE!

WARNING!

While shooting, keep your eye on the number which flashes up in your screen. This is the shutter speed, which the camera is setting itself. Occasionally in low light conditions it will be very slow and your picture may blur. Provided it is 125 or higher (250/500/1000 etc.) it should be fine, but beware if it shows 60 or less (30, 15, 8, 4 etc.) because you need to hold your camera really steady to avoid blur.

TIP – If you see these low shutter speeds, adjust your ISO to 800, which will increase the speed slightly.

>> That's it – now you can take pictures!!

To take picture 3 with the child on the right hand side of the frame:

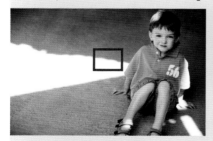

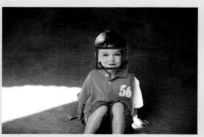

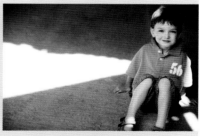

1. Compose your image with the child on the right hand side of the picture. You will notice that the red focusing square is in the centre of the picture, and if you took the picture now, the boy would not be correctly exposed or in focus, so...

2. Move your camera so that the red square is now over the boy's face. Press the shutter half way down, and this will lock the focus and exposure on his face.

3. Whilst keeping your finger pressed down, move your camera back to your original composition and press the shutter.

Setting Up Your Camera

What Makes a Great Background?

It's great to take a candid shot of someone; we've all had those moments where we suddenly see a child looking really cute, we reach for the camera and grab the shot. Occasionally we get a great picture, but how often is the result not quite as good as you thought it would be? The secret to getting really good pictures of people is to actually control the situation more.

If you can control the background and the light, then let the child play in your "set", you have a much better chance of taking a great picture. If you start with the child, without thinking about their surroundings – you may get distracted and forget about the dustbin in the background or the fact that the sun has just come out and is creating shadows all over his face – so make sure you've sorted these things out first. Then you can follow the child around within that area knowing that the chances are whatever you shoot is going to look good.

Most people look for flowers and trees – or stand someone in front of a sharply in-focus building. But these are not always the best backgrounds for people, as foliage and landmarks can detract from the person's face.

TIP – **I prefer out of focus backgrounds which complement people, using COLOUR and TEXTURE and emphasising the person.**

» It's important to work out WHERE you're going to TAKE the photos and WHERE the best LIGHT is

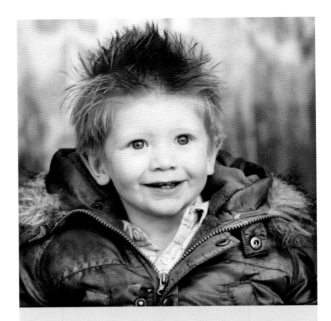

The background in this shot is a very scruffy piece of wet hardboard! Which out of focus, looks great with the colour of Lucas' hair.

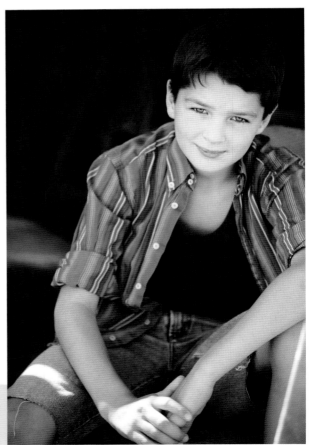

Rocco is sitting under the shade of a metal fire escape, on an old battered chair.

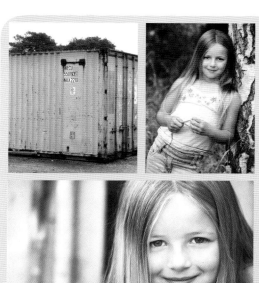

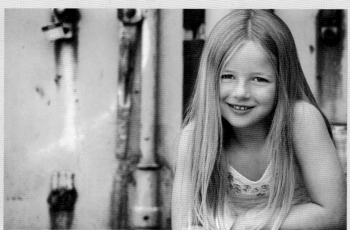

This is a lovely picture of Jessica by a tree, but you can get a very different picture of her by using an old wagon container! The texture and colour of the metal creates a more contemporary feel to the picture, and becomes much more a picture of 'Jessica', rather than a picture of "Jessica by a tree". The blue container naturally works well in colour, but also looks equally good in black & white.

Sarah is crouching on a concrete floor outside the glass doors of a shoe shop!

What Makes a Great Background?

What Makes a Great Background?

This is a very ordinary street on first viewing, but as you wander into it, there are all sorts of interesting shapes, colours and textures that will make amazing backgrounds particularly when they are out of focus.

This is why it's important to use a long zoom lens (75-200) and set your camera on 5.6 (or F4 or 2.8 if you like), because these wider apertures will give you much less depth of field – which means the background will be more out of focus, the further away you bring your subject from the background.

» One street can provide hundreds of backgrounds

Part of the fun of photography is finding the "right" background. But a background does not have to be beautiful or perfect – it can start off as the scruffiest piece of tin or wood, and suddenly become an amazing shape or texture, just by **YOU** seeing it in a different way.

Challenge yourself to look at things with an open mind and you'll be amazed at what you are suddenly seeing. How often do you go on holiday and arrive in the evening at your villa or hotel slightly disappointed? It's amazing the next morning when you open the blinds and suddenly everything looks inspiring and interesting.

The reason is often because you are tired and uninspired, and being creative people, we find it difficult to get motivated unless something fantastic is right in front of us!

It's just the same when you're looking for backgrounds. If it doesn't look immediately inspiring, look harder, change your attitude and believe that the ideal background is there somewhere! You've just got to find it!

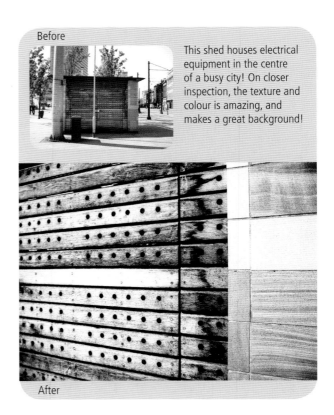

Before

This shed houses electrical equipment in the centre of a busy city! On closer inspection, the texture and colour is amazing, and makes a great background!

After

» Create a piece of art and then put your subject in front of it

Before

The bright colours and logo of this building will make a great background when cropped and shot at an angle. Placing a person in front of this with brightly contrasting clothes would look amazing.

After

Before

Place your subject a few feet in front of the background, tilt your camera, and provided you are shooting on a wide aperture, such as 5.6, your background will be out of focus and enhance the subject.

After

Before

Anything is possible!

The shadows and light patches enhance this picture by toning with the grey slate of the pillars and Soray's jeans. She is actually sitting on a pavement outside a shop – but the texture, shapes, colour and lack of focus in the background really make the picture work.

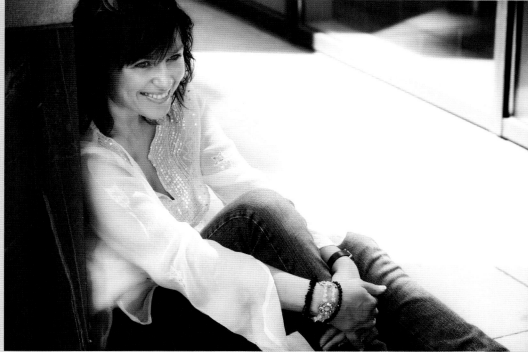

After

What Makes a Great Background?

Take your subject to the light, not the light to your subject!

I consider it my job to take the best photo I can of every person that is in front of my camera. I firmly believe that natural light is the best way. Flash photography really ruins a picture, unless you use massive softboxes in a studio. But using lights in a studio can be very tedious, as you constantly have to create new backgrounds yourself, and restrict your models to certain areas of the studio, and this can get very boring for creative people!

Why bother with all that hard work when you've got an abundance of natural light outside, with every background you ever wanted?

Working in poor light is par for the course in my job as a photographer, and I have adapted my photography to suit the poor light, so no matter what the conditions are I can always get a great photo.

Many people will use "fill-in flash" in these conditions, which I feel is the most unflattering light you can possibly use! You may get a beautifully lit picture, but every line and blemish will show up on your subject's face. It's far more flattering to find the **RIGHT LIGHT**.

These blue factory doors make a fantastic background due to their vibrant colour with the added benefit of top shade to create even light.

Note how perfectly exposed the boy's face is. He is under the shade of a roof, which keeps the direct sun off him. The sun keeps going behind a cloud, but when it is out it catches on the door and washes out, because the exposure has been taken from the boy's face. If a general exposure of the door had been made, the sunlight would be less washed out, but the boy's face would be darker and a less flattering result would have been achieved.

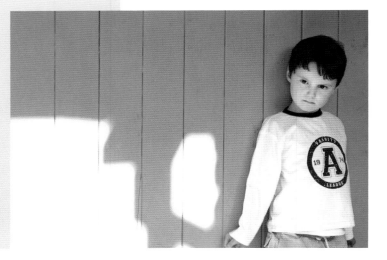

So where do you find the RIGHT LIGHT?

I learnt by accident that positioning people in doorways, or under cover, creates the most beautiful and flattering light. I spend my life looking for barn roofs, porches, and any suitable topshade, and it works every time!

Every house has a door! Open the door, stand outside and shoot in towards the house. Place your subject on the hall floor (after removing the "Welcome" mat!), and focus on their face.

TIP – **Make sure your subject is in the shade, in even light, and out of any sunshine that may be there. Take the exposure from their face (see page 15) and I can guarantee the light will be flattering.**

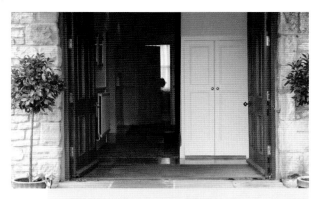

Both of the black & white shots on these pages were taken inside the doorway pictured above!

Michelle (below) was lying on the doormat, and Beccy (previous page) was sitting against the cupboards in the background. They were both shot entirely in the natural light from outside without any flash or reflectors, but the exposure was taken carefully from their faces (see page 15).

Natural Lighting

Sunlight v. Shade

Sunlight can be beautiful in the background of a picture, and really lift the image, however, sunlight on most faces is not flattering, and can lead to harsh shadows and squinting. Many models in magazines look great with sunlight over their faces, however models usually look good in any light. Most lesser mortals need soft flattering light on their faces, which can be achieved by placing them in the shade and taking the exposure directly from their face. (see page 15).

Beaches are a fantastic location for photography because they are very inspiring places, and also because children can be at their most natural, allowing you to take candid, fun pictures. Unfortunately there is often no shade on a beach, so I solve this problem by shooting into the sun, which effectively puts your subject into the shade. It is crucial when doing this that you take your exposure from the face, otherwise the face will be dark.

It was a very cold but bright day when these pictures were taken, therefore I placed Kiah so that the sun was behind her, creating beautiful light in the background but more flattering light for her face. Because children run around it is not always possible to keep their faces in the shade, but provided she is not looking directly into the sun, the picture will still work.

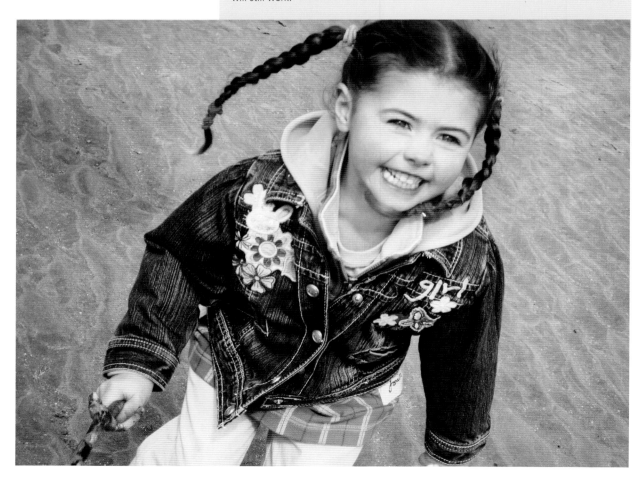

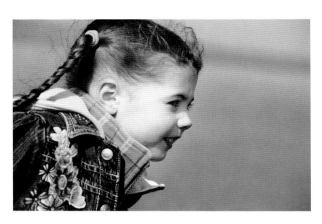

ANNABEL'S TIPS

Improvise

If you can't find any shade, ask a parent, or friend to hold a towel or jacket over your subject to block the sun – this is just as effective.

Even the picture with her eyes closed works well!!

Sunlight v. Shade

Different Compositions

Try to take a variety of different compositions rather than firing off lots of shots of the same thing. It's much more interesting!

Many people feel very uncomfortable in front of the camera, and they feel much more relaxed if they don't have to do much! So if you can take a range of different compositions while they are in the same position, it is much more relaxing for them.

Similarly if you follow a child round and keep taking snaps – you need to remember to keep recomposing to stop your pictures all looking the same.

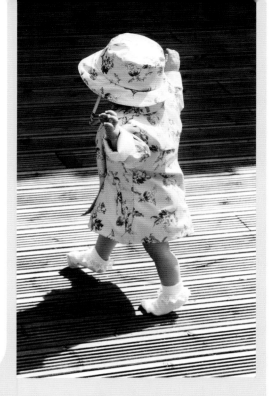

Harriet is wandering around the decking, while I am making sure I change the angle of my camera constantly, and zoom in and out, to create a variety of different shots, which were all taken within seconds of each other.

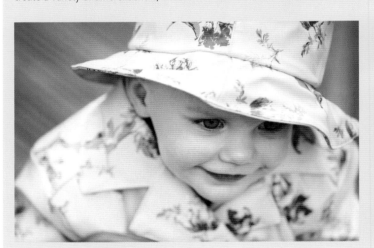

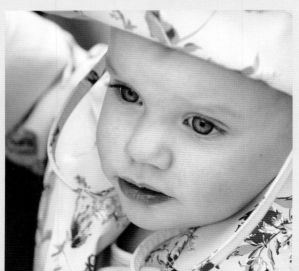

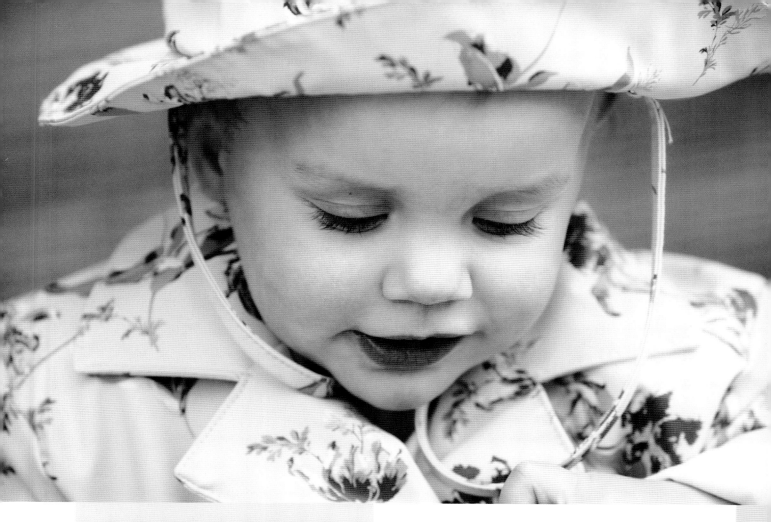

If you use a long zoom lens such as 70-200, you can stand back and zoom in on the child while she is distracted, without her noticing you. If you use a shorter lens, you will be too close to her and may not be able to get such "candid" looking shots.

Cropping tightly really emphasises the child's features

TIP – **Using a 75-200 zoom lens allows you to compose very quickly and take a range of different shapes and crops within seconds.**

TIP – **Starting with a wider shot helps to establish the shot, and then moving in closer gives a whole new dimension to your pictures.**

TIP – **Try to alter the position of your camera.**

TIP – **Check there are no distracting objects in the background, and move your position to avoid them.**

Different Compositions

Cropping

Careful cropping can make all the difference to a picture. Try to crop in camera as you take the shot, rather than think about it later on your computer, unless you want to change the format to a square or panoramic picture. But even in this case, you should think about the format you want, as you shoot the image, knowing that you want to crop it to this shape later. This way you can make sure you are including or excluding everything you need to.

TIP – Experiment with different crops and see which ones you prefer. You will find some will work better than others, but it depends very much on what you are photographing and where the picture will be used later.

Try to restrict the amount of pictures you take – this really helps you think about composition. Force yourself to go out and only allow yourself 30 pictures as a test – you'd be amazed at how much better they are because you know when you press the shutter it's really important.

TIP – Don't just shoot haphazardly and "hope there's a good one" out of the hundreds you've taken! Make sure there are lots of good ones – by really thinking about how you shoot.

>> I've never learnt any rules, so I don't actually know when I'm breaking them – I just make it all up as I go along!

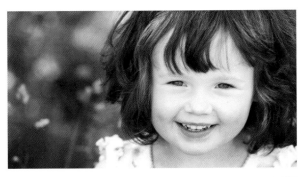

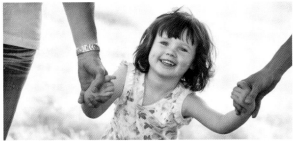

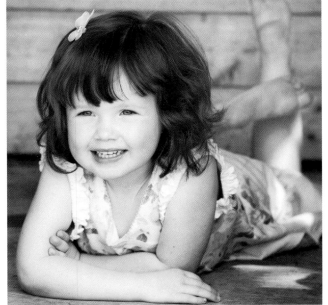

Break the Rules

One of the most important things in photography is to break all the rules! There are so many rules in photography, and most of them are very boring!

>> **If it looks right I take it – if it doesn't I move it until it does!**

These images break all the rules – don't be afraid to crop half her face out (above) or have lots of space at one side (below) Don't worry about mixing your colours or cropping half the arms out of shot, this just enhances the face even more, and creates a great picture.

Make Your Photo Session Feel Like a Fashion Shoot!

It's absolutely vital that your subjects are enjoying themselves in order to get great photographs. Most people say they hate being photographed. They believe they are not going to look good in a photo due to their previous experiences.

When people are nervous or unrelaxed, they will look worried and apprehensive in the pictures. They will feel tense and it will show.

That's why it's so important to develop a relationship with your subject. I never take my cameras out of the car until I've had a coffee with my clients, chatted to them, walked around the locations and rifled through their wardrobes! By that stage, I am getting on really well with my clients, and they are as excited as I am about their photo shoot. Then as we go through the shoot, making it all up together, we are all having a great time – just as these pictures show! Quite often, as I am taking a photo, something in our conversation makes us laugh, and if you're ready for these moments – they often result in the most natural shots!

If you know your subject too well, i.e. your partner or your children, it can be more difficult to photograph them than a complete stranger! Your own family will often have less patience when you try to photograph them, because they know you, and you are just not as interesting as a new person taking their photo! This is often why parents can't believe I can get such nice pictures of their children, when they can't. Believe me, I find it very difficult to photograph my own daughter, simply because she doesn't always want to do what I want her to do! So don't worry if this is your own experience, it's quite normal!

TIP – **If you want to practise taking good pictures of children – borrow your friends.**

TIP – **If you are photographing someone for the first time, get to know them! Spend around an hour before the shoot having coffee, and chatting about their ideas.**

You could even do this with your own teenagers – try taking them to a completely different location, and treat them like models – change their experience of being photographed and watch the results!

Ask your subjects to bring their favourite images from magazines and discuss the pictures with them. What is it that they like about the ones they've chosen? It doesn't necessarily mean they want to look exactly like the model, it may be that they like the texture or colour of the picture.

» Most people want you to capture how they feel, not just how they look!

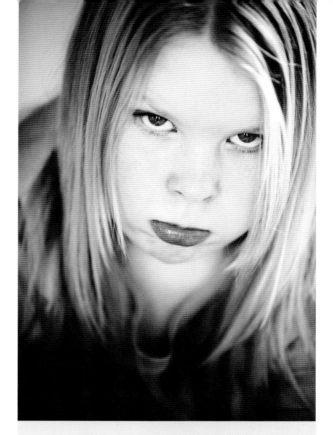

It's not always easy to take good photos of your own children, and even though this shoot did not go exactly as planned, I got a very amusing shot of my daughter which summed her up exactly at the age of 13!

TIP – **Usually it's the feeling in the picture that has caught their attention.**

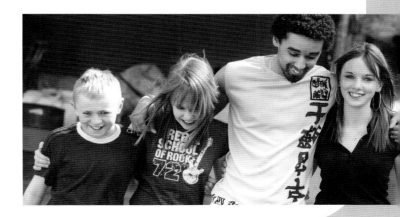

Make Your Photo Session Feel Like a Fashion Shoot!

If your subject is a teenager or adult it's important that you direct them, as they are unlikely to know how they will look good in a photo.

TIP – **Don't expect people to feel comfortable standing up in a space. They often need something to lean or sit on. Ask them to sit any way they like, then just tidy them up! This way they feel comfortable to start with and less exposed, which will make them feel less vulnerable.**

Asking someone to crouch down is natural for many people, in that they know how to do it so it doesn't feel alien, like asking them to "pose". When they are crouched you can then ask them to move around so you can see where they look good or bad, and can shoot accordingly. Try turning their head slowly first to the left and then to the right – there will be a point where they look their best. Don't be afraid to keep trying different things.

Many photographers worry that their subject will think they don't know what they're doing! Don't worry! I always tell people I am making it up as I go along! Because I am! I will have found the best backgrounds, most flattering light, and most suitable clothes, and from then on we're working together to create the best pictures! This creates a much more fun experience and you'll get better results.

» People are much happier and more relaxed if you take control!

CHILDREN are very different. You can actually direct a very young child in many situations, but more often than not you have to create a safe environment with the right light and background, and then provide something to play with, so you can capture natural shots as they play.

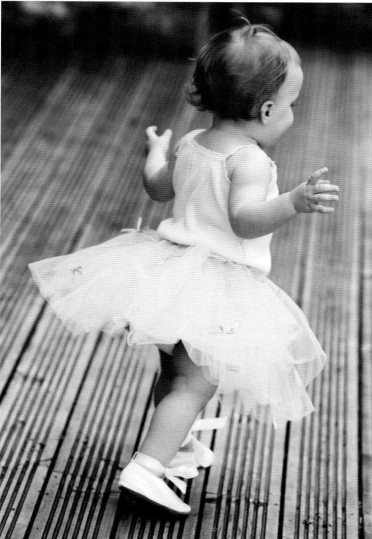

» Giving a child something to do will allow you to shoot candidly while they play

Harriet is actually kicking a football around the garden – but with careful cropping we can get great shots of her without seeing the football. We would not be able to just ask her to run around and expect to get shots like these – she needs a purpose, whilst giving you the opportunity to shoot.

Don't forget to take shots from behind too! The back of a child can be very cute, and capture another part of their personality rather than having all your shots of the child looking at you.

Directing Your Subject

Enhancing Your Images

Today's digital cameras are so sophisticated that they can create amazing results straight out of the camera. However, they are often rather flat and need to be lifted to create the brightness we used to get with film. This is easy with the wealth of software now available, from the basic programs supplied with most cameras to more sophisticated programs such as Photoshop.

There are many simple programs which involve pressing just one button to change your images from colour to black & white or sepia. You can also press a button and your image will instantly become brighter, and many other options. However these can be very limited, and usually only give you a choice of 9 or 10 ways to change your image, and most limiting is that they only allow you to change the whole image – you can't usually work on a specific area.

In my experience, Photoshop is fantastic but can be very confusing, as there is so much it can do, and so little we photographers actually need! It's like your camera – just learn to use the few things you need and suddenly it becomes a whole lot easier!

TIP – **If you want to take up photography professionally, you really need to learn only the simplest things, otherwise you will spend all your time on your computer and not enough time taking pictures and running your business – be warned!!**

>> If you take your pictures in soft, flattering even light, you will get much better results when you try to enhance them later

Before

After digital retouching in Photoshop

>> For total control you will need to use Photoshop

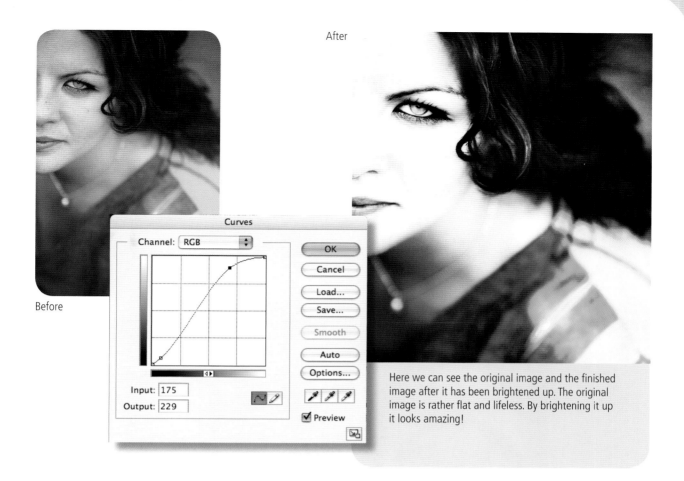

After

Before

Here we can see the original image and the finished image after it has been brightened up. The original image is rather flat and lifeless. By brightening it up it looks amazing!

Brightening Up Your Image

Open your image in Photoshop, go to "IMAGE" then into CURVES, and just lift the line to create a very slight S curve. This will alter the contrast in the picture, and can create some amazing results. It will tend to brighten up the colours and is particularly effective if the person is wearing bright colours. Experiment!

TIP – **Be careful not to increase the contrast too much or you will lose detail in your image. It's best to alter the curves very slightly, then save the change, and go back into Curves again and do a little bit more. Doing this several times, rather than all at once, will result in you losing less information.**

ANNABEL'S DIGITAL TIP

Limit Your Retouching

You can't make a great picture out of an image which was not great to start with. As a friend of mine once said to me – it's like putting lipstick on a gorilla! Try to do as much as possible when you actually shoot the picture in the first place, so it only needs a very small amount of retouching.

Enhancing Your Images

Simple Removal of Blemishes

Sometimes an adult will have a spot on their face, or a child may have a graze or scratch. These are very simple to remove with the PATCH tool.

» Click on the Patch tool.
» Draw an area around the spot or scratch.
» Drag this area over a similar but clear area of skin and click
» Miraculously the spot will disappear!

This is a very useful technique for teenage acne and your client will appreciate the time you take to enhance their image by removing their spots. It is also great for taking out little grazes on a child's skin, as it's amazing how many children have just fallen over the day before their photo shoot!

Before

After

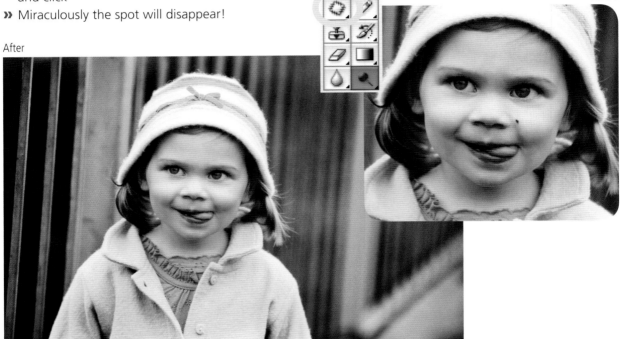

More Advanced Removal of Lines and Wrinkles

Most adults have slight lines around their eyes, and because today's digital cameras are so detailed, these can be over emphasised in the original picture, so much so that the subject would hate the picture, and you would probably give them a phobia about themselves by showing them the untouched image!

Just increasing the contrast in Curves (as shown on page 33) is not sufficient for most adults. You need to do more! Even children can have enhanced eye bags on a picture, because the camera will increase so much detail, and often it's necessary to soften areas of skin below the eyes of children. This is quite a sophisticated technique in Photoshop and requires some patience (see facing page).

I would never show a client an untouched image, because the camera picks up everything, and amazingly makes it seem more detailed than it actually is in real life. (That's what I tell myself about the ones I have of myself anyway!).

TIP – **Do not remove eye bags and lines entirely – or the person will not recognise themselves! Removing them completely will give them the appearance of a longer face. You are only trying to reduce them slightly not remove them altogether.**

Professional Technique

For more detailed lines use a second LAYER.

» Go to "LAYER" on tool bar.
» Create duplicate layer.
» Then go to PATCH Tool.
» Draw around the area under the eyes.
» Drag this area down over the cheek area, and this will now cover the original area.
» Go to Opacity on the Layers palette, and take the slider down until you see the original lines appear under the eyes – you can control how many lines you want to show with this slider!
» Then go back to the top tool bar – click on LAYER, and then "Flatten Image".
» Then save your image.

After

Simple Technique

For lesser detail you can use the DODGE Tool.

» Make your brush size big enough to work on the area you want, but not too big that it crosses the eyes.
» Gently brush across the area under eyes until it looks lighter but still looks natural and blends with the rest of the face.

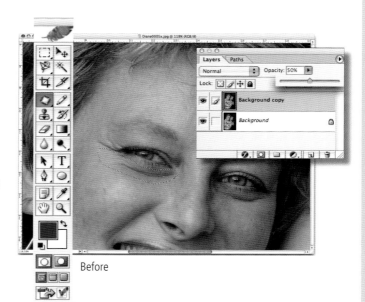

Before

After

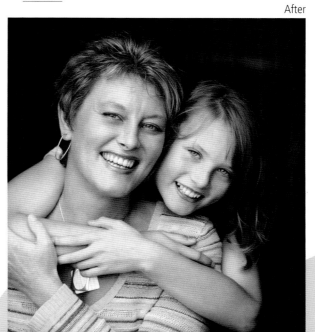

» You need to constantly keep your eyes open as the trends change!

Some images look better in black & white than others. If the image is full of bright colours, then it will usually look better as a colour image, as changing it to black & white will obviously remove all the colour! However, it's really nice to throw the odd black & white image in just to break up the set, and as I usually photograph people by shooting sequences of images, a few black & white pictures tend to break up the sequence effectively, particularly I find, if the people are looking away from the camera or interacting with each other.

Trends change constantly, and a few years ago, most people preferred black & white pictures of themselves. I feel this was because they looked less "real". Everyone was used to seeing themselves in colour, because this was usually the film of choice for compact cameras. So when they saw themselves in black & white they preferred it because it was different.

Nowadays, colour has had a huge revival, simply because digital technology has meant we can make the colour images much more punchy and vibrant than we could with film. Bright colours are also very trendy for children's clothing and are being used more and more in furnishings. This means that people are seeing bright colourful images in magazines, and therefore have a tendency to choose colour pictures over black & white. But of course, this will all change again in a few years and we'll see black & white making a comeback!

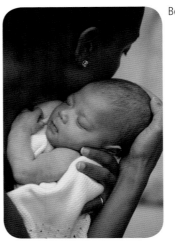

Before

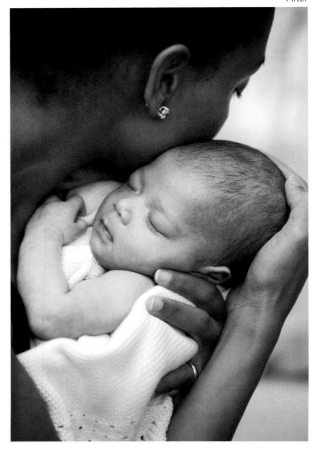

After

ANNABEL'S DIGITAL TIP

Work on the Colour Version

You will get better results if you do your alterations to the colour image first, and then change to black & white afterwards.

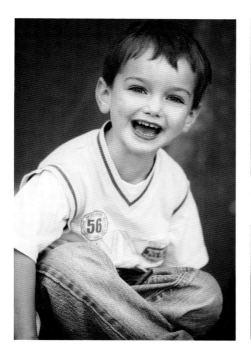
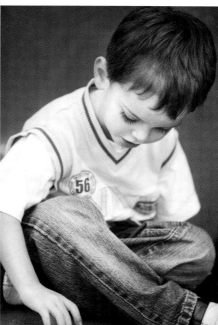

Both these shots would work well in colour, but to break up the set I have converted this one to black & white.

It is as if the colour shot enhances the "reality" and the black & white enhances the calmer mood.

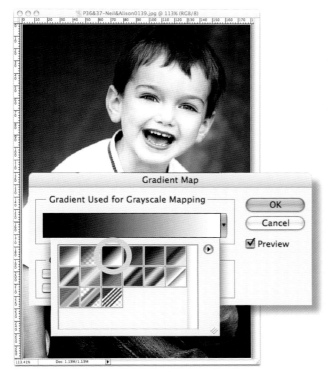

Changing a Colour Image to Black & White

After you have worked on your images – by brightening them and/or removing lines and blemishes, there are many ways you can convert your image to black and white.

Everyone has their favourite method and one of mine is to use the Gradient Map.

Go to IMAGE, then ADJUSTMENTS, then GRADIENT MAP.

Click on the little arrow and then you will see a series of squares – click on the third one, and the image will change to black & white.

Converting to Black & White

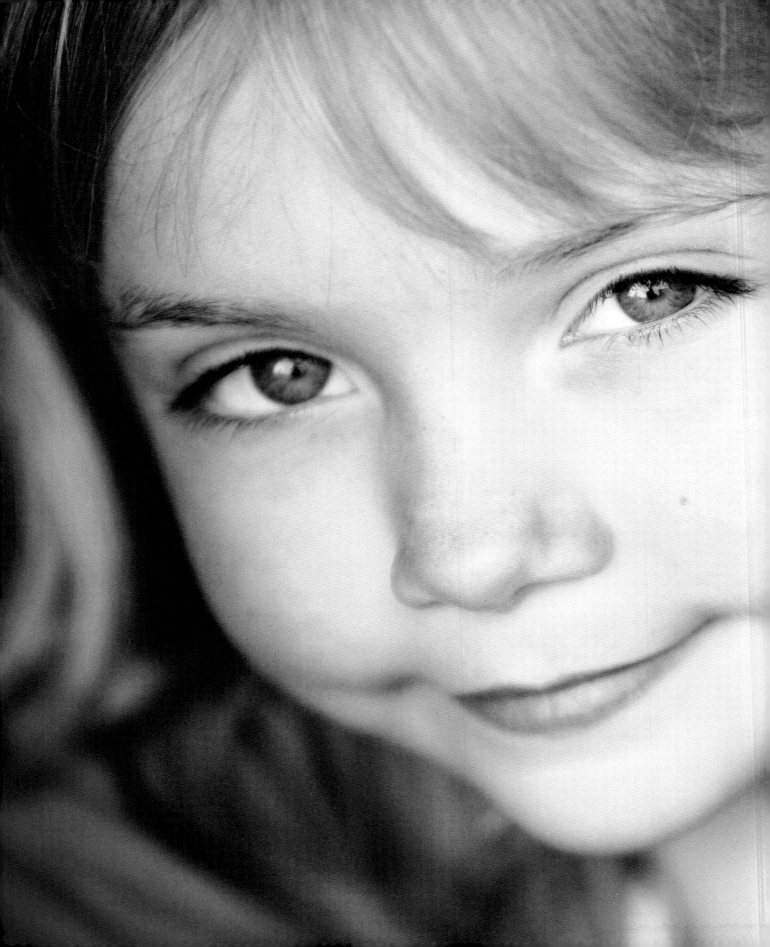

2 99 PORTRAIT IDEAS

1 Children

2 Teenagers

3 Adults

4 Families

Preparation is the key to a successful shoot. If you follow my tips every time, you will find that you don't have those "what shall I do now?" moments, because you will already have planned what you are doing and know where you are going next.

» Divide your shoot up into small sections each with a different background and clothes.

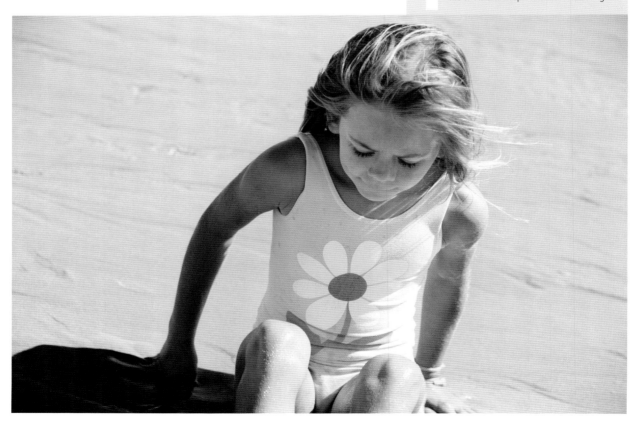

Becky is wearing a different outfit for each of the 3 different locations to add variety to the shots and keep the shoot interesting.

Directing

Your clients will be much happier if you take control. They are looking to you for direction and guidance

Make each section no longer than 10-15 minutes, depending on the age of the child. Young children get bored very easily, and the secret to a successful shoot is to keep them interested.

Make sure you have a refreshment break every time you change the location and clothes, so that both you and the children are fresh for each section of the shoot.

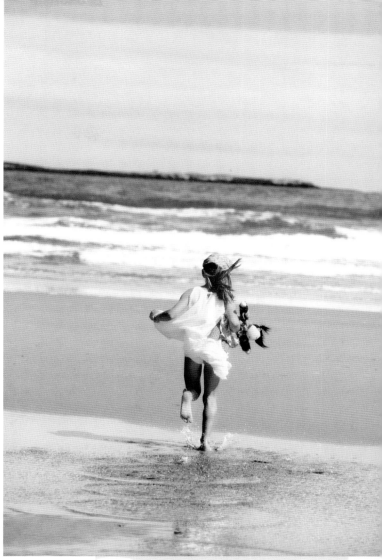

I have taken "safety shots" like this full face smiley picture, in the house doorway at the beginning of the shoot, so once we go out on the beach I no longer have to worry about getting the smiley pictures.

I can let Becky do whatever she wants while I shoot candidly and capture more spontaneous pictures because I have my safety shots.

» Planning a shoot well makes it easier to keep a child happy and engaged.

When you have established your relationship with the children, go out and look for your locations.

Directing

I always try to take a series of "safety shots" at the beginning, which will be more "posed" than the ones I take later on. Once you let a child loose in the garden or on a beach, you may find it more difficult to get them to sit and smile at you, so doing this first means you can take more natural pictures later in the knowledge that you've already got the "perfect smiley picture" that most parents want.

Look for a doorway or porch with shade from the sun. Starting in the house is more comfortable and familiar to children, and a doorway usually helps to contain them in a "safe" environment, as they may feel more nervous at the beginning of the shoot.

Getting the perfect smiley close ups that every parent wants, is much easier if you do it first when the children are often more co-operative because they haven't become too familiar with you at this stage.

ANNABEL'S TIPS

Take Control!

Don't feel you just have to wander round snapping children and HOPING to get a good photo, they actually love boundaries and instructions, which if used in a fun way can ENSURE you get a good photo!

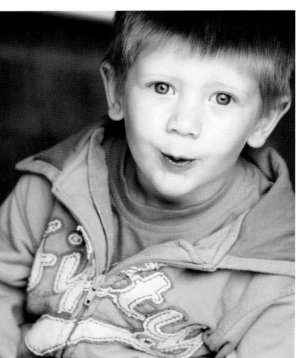

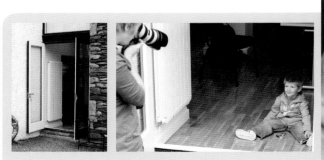

The shots on these pages were all taken in the shade of this doorway, which creates flattering soft light, out of the direct sunshine.

CHILDREN

42

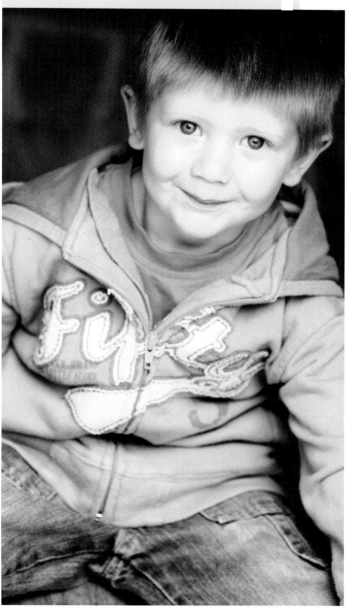

Seconds after this photo was taken, 2 year old Lucas no longer wanted to sit still, and ran off into the garden!

4

Clothes

Try to start with the clothes that the child feels comfortable in.

If you want a very young girl to sit down don't use short skirts, as if she doesn't want to sit still, your pictures are likely to be spoilt if you can see her nappy or knickers! If you make sure they have longer skirts or trousers on at this stage, it's one less thing to think about!

Even the smallest garden can have some great locations.

Backgrounds

Once you've done your "safety shots", given the children a drink, and changed the clothes you can now move outside and change the feel of the shoot.

Most parents will want pictures of their children outside, whether they are in their garden, a field, park or on a beach. These environments will give you much more scope for natural photographs, and the children will enjoy playing while you shoot.

Most gardens usually have a garden shed or playhouse and placing the child inside the shed shades him from the sun and creates a beautifully lit image.

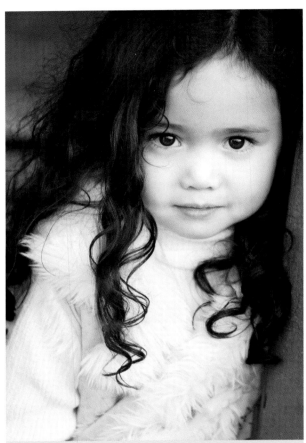

Playhouses are often full of toys which can be distracting in the background so placing Mia in the shaded area just inside the doorway and cropping in tightly from an angle, works perfectly.

» You don't have to shoot against flowers and trees to get great pictures! You only need the smallest of areas to use as a background, and then you can crop out what you don't want to see!

Composing

In a small garden there may be lots of distractions you don't want in the picture – compose the image tightly to avoid them.

Try moving your subject as far as you can from the background, so the distractions are well out of focus and become shape and texture.

Lighting

Make sure you find your background first and check it is in even light (see page 21) so when you let the children play in front of it, you'll be able to get plenty of pictures without worrying about distractions or splashes of light.

Here Angus is sitting under a small shrub to shade his face, while I shoot from above, using the gravel on the drive as a background, whilst cropping out the cars behind.

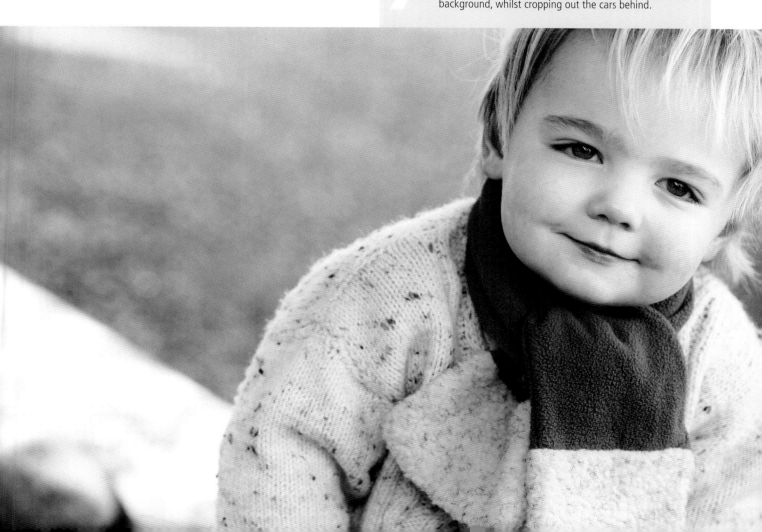

Fields provide wonderful backgrounds for pictures because they contain so many natural areas.

Directing

Try shooting in long grass, by asking the child to pick some grass or a flower for their parents. If you get the child to crouch down and shoot from above, you only need a few strands of grass to make it look as if the field is in full bloom.

ANNABEL'S TIPS

Ask First!

Do ask permission first if the field does not belong to your clients, as the farmer won't thank you for ruining his crops! You can often get great results just by using the immediate area inside the gate, where you can use the rest of the field as a background, but only tread on the grass at the edge.

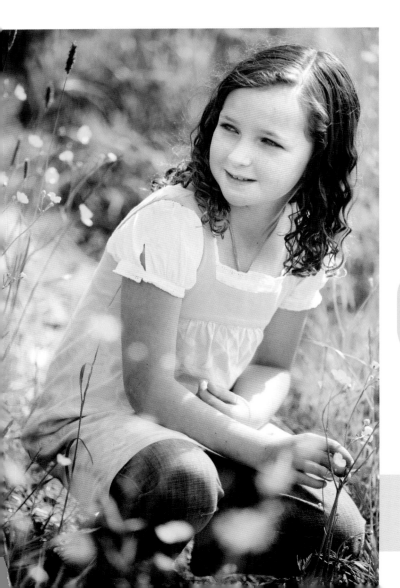

Clothes

Dress the children in clothes that they can play in, run, climb trees etc, such as jeans, shorts etc. White clothes are likely to get dirty very quickly so be warned!

For a romantic, nostalgic image, girls look lovely in colourful summer dresses in fields of grass or flowers.

8

Note how different the light is in this picture. If Clay was walking towards the camera he would have been squinting in the harsh light. and the picture would not have worked).

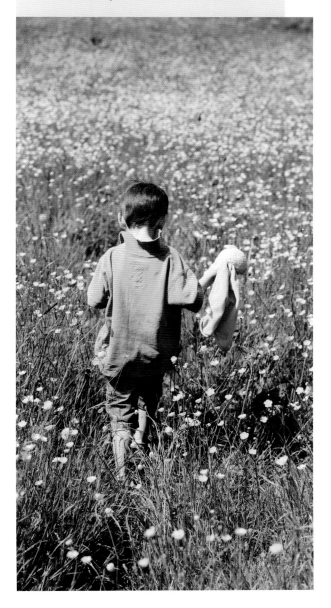

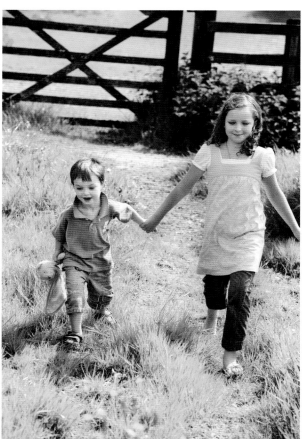

This is a very bright sunny day, and Robyn and Clay are both facing me with the sun behind them to create soft shaded light on their faces. The colour of Robyn's dress complements the buttercups perfectly, whilst the colour of Clay's T shirt provides a total contrast, which still works.

Lighting

If you are struggling to find shade, you can also ask a parent to hold a coat above the child's head, which will create enough shade for you to get a great picture. Any sunlight in the background will just enhance the picture so don't worry about it!

Take a football to a park to keep it fun, and ask the parents where their kids usually play, as using these areas in the pictures will mean more to them as they get older.

» Keep your shoot fun! If you make everything a game, the kids will enjoy it and you'll get happy photos!

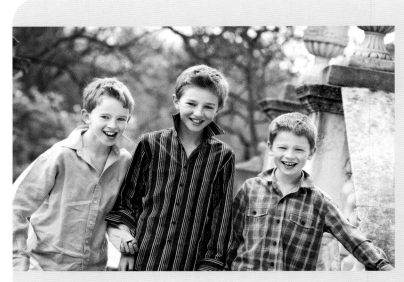

I've placed the boys on the steps and told them that in a moment they are going to jump off the steps towards me. Then by asking "Are you ready? Are you sure you're ready?" they wait patiently to jump, giving me a great opportunity to catch their smiles of anticipation! It works every time!

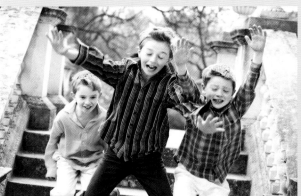

As they jump, you can't possibly know what will happen, so you need to take as many shots as possible, and see what you get! As a picture on its own this may not have worked because two of the boys are looking down, but as a set of action shots, all three pictures work perfectly together.

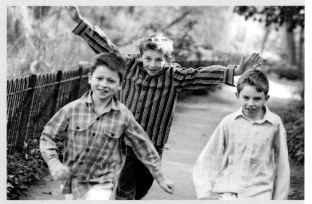

I've asked the boys to run towards me. The fact that one of them is slightly out of focus does not worry me, because it adds a feeling of movement to the picture, whilst still keeping the background out of focus and therefore placing the emphasis on the kids.

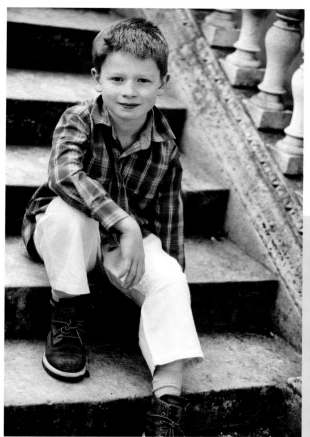

Backgrounds

Parks around a stately home often have a multitude of different backgrounds, from trees and grassy areas to more formal features such as arched doorways and stone steps.

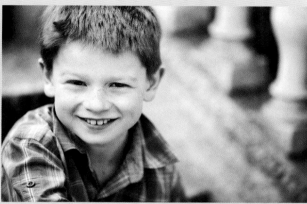

12 The formal stone steps in this picture provide a beautifully neutral light tone, emphasising the colours of his hair and clothes perfectly.

Zooming in close and altering the image to black & white in Photoshop emphasises his features, while the beautiful texture of the balustrade is thrown completely out of focus using my aperture set on F2.8.

» Use trees for topshade to create soft, even light.

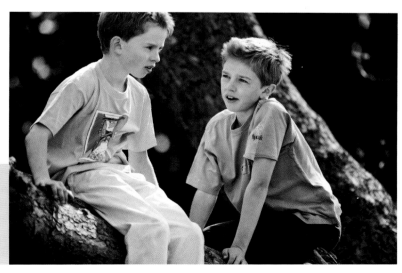

13 Let older kids climb trees in the park and take candid pictures of them interacting together for a totally natural image.

Beaches make a fantastic location because of the light and the relaxed atmosphere.

» Set up your scene and then shoot the children playing and being natural

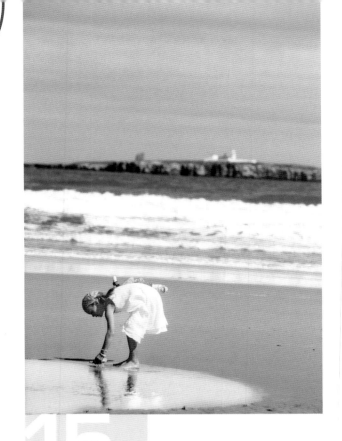

ANNABEL'S TIPS

Top Location?

Beaches are one of my favourite locations. Why?

1 *Because children are usually so happy when they're on the beach that they don't notice you taking photos.*

2 *You can take photos on a beach in any weather and they will still look good!*

3 *You can include a combination of landscape and people at the same time, which is quite difficult in many other locations.*

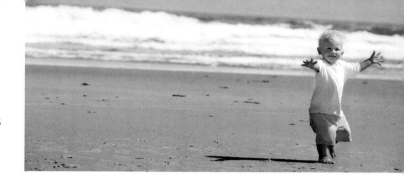

Backgrounds

Beach backgrounds always look good in pictures and people usually love images of sand and sea in their homes.

16

All the children are happily absorbed in exploring the sand and totally oblivious to my camera, which enables me to move around and shoot as they play.

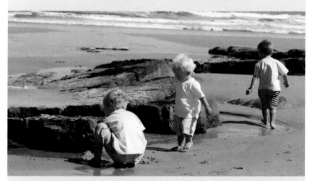

Lighting

The light on the beach is usually really good because of the reflection from the light sand.

Try to shoot your pictures into the sun to avoid harsh light on the children's faces, and expose as shown on page 15.

TIP – **Remember they don't have to dig holes in the sand in just one area you CAN move them into the right light!**

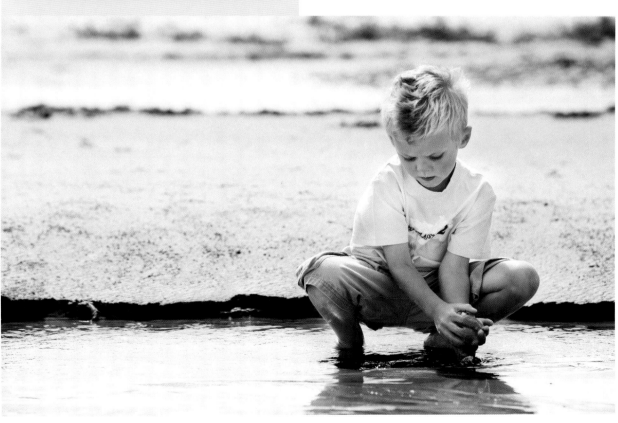

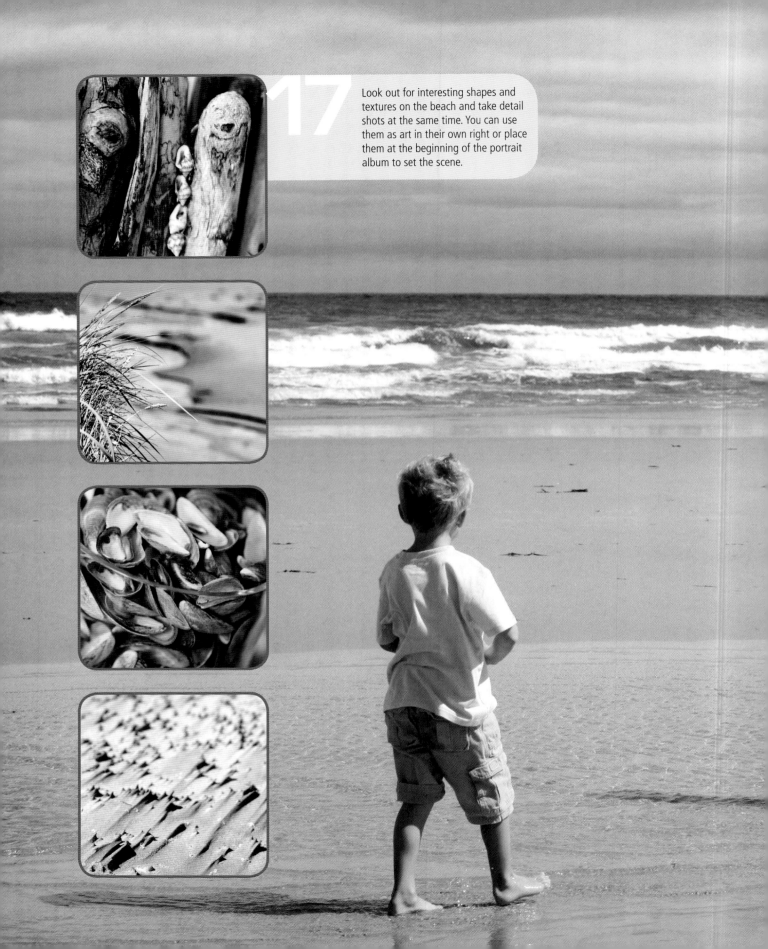

17 Look out for interesting shapes and textures on the beach and take detail shots at the same time. You can use them as art in their own right or place them at the beginning of the portrait album to set the scene.

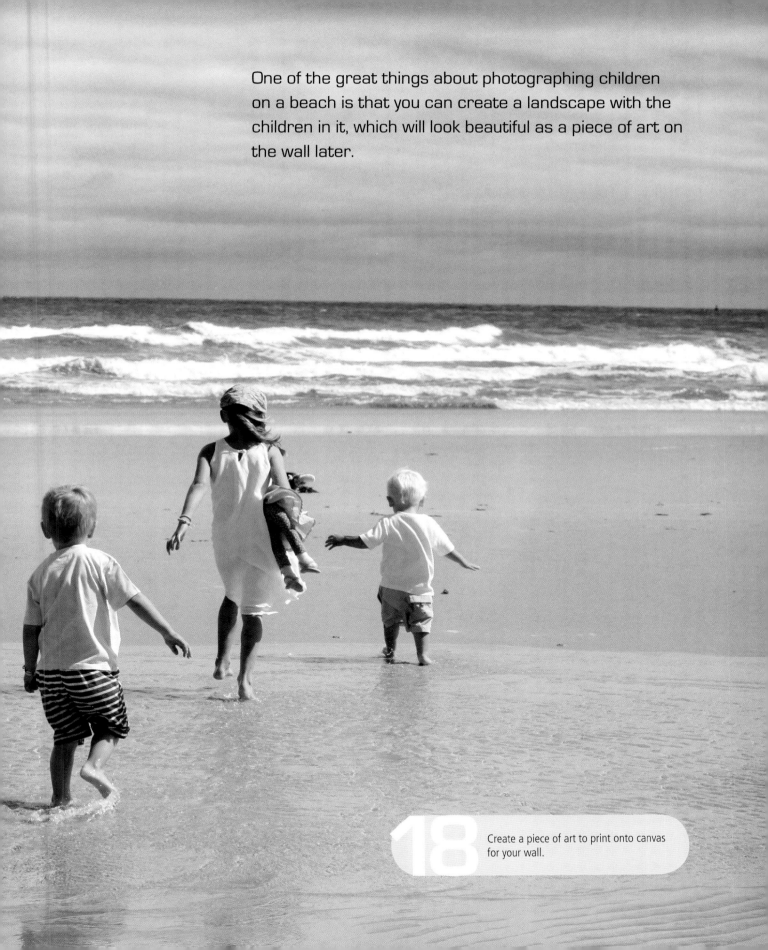

One of the great things about photographing children on a beach is that you can create a landscape with the children in it, which will look beautiful as a piece of art on the wall later.

18 Create a piece of art to print onto canvas for your wall.

You can find these kind of locations anywhere, you just need to look for them!

Directing

Once you have used the more traditional backgrounds, you will have gained trust and respect from your clients, and then you will be able to suggest taking photos in locations which are not necessarily attractive at first glance!

If you use the unconventional backgrounds at the start of a shoot, many people will not understand what you are doing, which is why I like to leave them until later, when my subjects are feeling much more confident!

19

Poppy's bright red bandanna contrasts beautifully with the green peeling paint of the door behind her. Note the difference between these two pictures – both are shot on F5.6, but the background is much more out of focus when Poppy stands further away from the door. Both shots work well in this case as the peeling paint adds to the picture, but be careful to keep less attractive backgrounds out of focus.

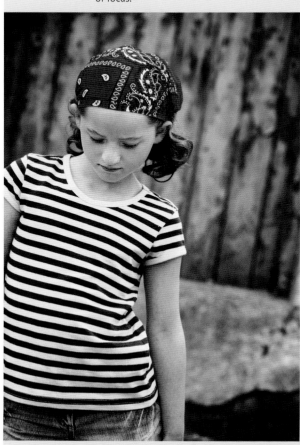 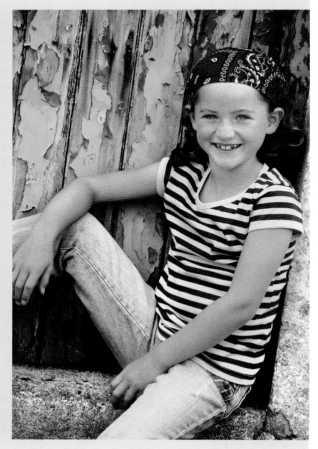

Backgrounds

I love using the texture and shapes found in the most unlikely of places. Old wagon containers, tin doors and anything with an interesting colour or texture can be amazing as a background, particularly when it's out of focus.

Clothes

Try to use bright colours in these locations as they work really well. I always try to use clothes that either blend or are a complete opposite to the colours of the background.

The pictures on these pages show clothes which contrast strongly with the backgrounds, but are very effective because of the dramatic colours, adding vibrancy to the images.

Georgia and Sadie are standing in front of two different wagon containers. The bright blue and yellow colours together with their individual textures make fantastic backgrounds, contrasting strongly with the colours of their clothes.

ANNABEL'S TIPS

Permission

If you are using locations in a private place such as a factory or industrial estate it is vital you get permission from the owner, and you should also have personal liability insurance if the area is likely to be dangerous. Make sure the parents know that they are responsible for looking after their children at all times.

Industrial areas are perfect for bright abstract backgrounds, which become great shape and texture when out of focus.

Composing

Try placing your child at the edge of the frame and use the diagonal line to create a magazine style look.

I tilt my camera to the left slightly, but experiment with the angles and always remember to crop in camera.

You will achieve better results if you spend time composing your image in camera and it will save you time later by not having to crop the image in Photoshop!

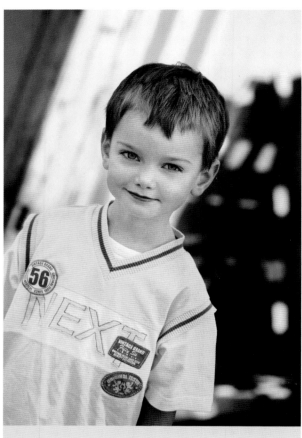

Clay is standing in front of a blue container which has become very overexposed in the sunshine, because the exposure has been taken from his face. The blue and white top he is wearing blends perfectly with the washed out look of the background for the same reasons!

22

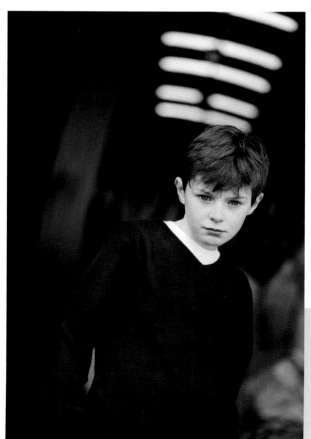

Harry is standing in a warehouse which has roof lights in the ceiling creating amazing shapes when out of focus in the background. His clothes have been chosen deliberately for him to blend with the background and draw attention to the lighter areas of the picture such as his face and the skylights.

23

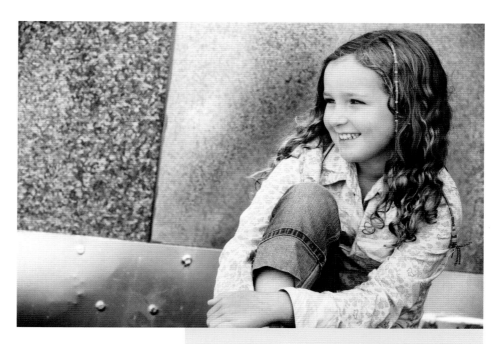

Clothes

The images on these pages show clothes which blend with or complement the background.

24

Robyn is sitting in front of some shiny metal doors and the soft blue and white colours of her clothes complement the silver of the metal.

25

In the first picture Lucas is playing against the green railings which match the green of his jacket perfectly with the orange areas providing a great contrast. In the second picture the colours are reversed, showing how the jacket works equally well against the orange wagon container for the same reasons!

There is nothing like the warmth and sunshine of a spring or summer day; it makes photographing children a whole lot easier, because they are happy to stay outdoors and play. However when the weather is colder life becomes a bit more challenging!

Clothes

Hats and scarves can look great in pictures, and it's far better to wrap up warm, than let the kids shiver. Blue skin and red noses do not look attractive!

ANNABEL'S TIPS

Enjoy Yourself

» Go out sledging! Buy some bright plastic sledges and take pictures of the kids having fun.

» Keep them warm!

» Photograph them with their hats on. This will add extra variety to your shots and stop kids getting cold at the same time!

26

Olivia's trendy hat really frames her face and emphasises her lovely features.

CHILDREN

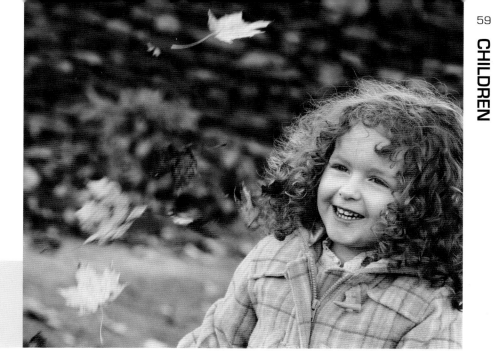

Holly's hair looks gorgeous against the colour of the Autumn leaves.

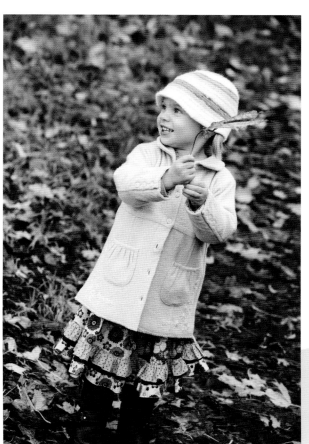

ANNABEL'S TIPS

Colours of Fall

Pile up some autumn leaves and let the kids throw them up in the air or at their parents or even at you!

Directing

It is even more important to play games and keep the children occupied so that they forget how cold they are!

Eliza doesn't notice the cold because she's so well wrapped up, and her hat and coat look great in the picture.

Wet weather is every photographer's nightmare. But it doesn't have to be if you rise to the challenge! Look on the bright side and rainy days usually mean an overcast sky – which is great for soft even light. If you are used to working under top shade, as I am, then top shade suddenly becomes a rain cover!

Directing

Let children jump in puddles, but make sure you do this near the end of a session, as they are likely to get their clothes and feet wet!

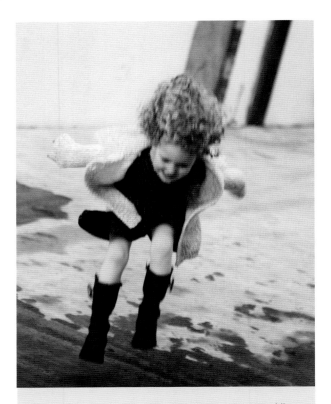

Georgia is enjoying jumping in puddles. Because it's such a dark day, this image is slightly blurred but I think it's the movement that makes the picture look so good! Remember to break the rules – it's much more fun!

Try to keep kids dry under an umbrella or some sort of shade, for as long as you can!

Shooting

Make sure you have a lens shade on your camera. These are intended to keep the glare of the sun off your lens, but I find they are equally useful for keeping the rain off!

Always carry your camera with the lens facing down and try and hide it under your jacket in between shots, to avoid rain drops on the lens.

CHILDREN

Composing

Try photographing children with their hoods up if it's raining - a hood will frame their face and emphasise their eyes, as well as keeping their hair dry!

30

Eli is walking through the rain with his Mum, and it doesn't bother him at all!

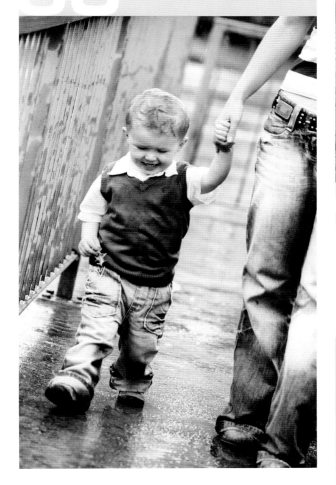

31

Poppy is wearing her hood up in the rain, which frames her face and highlights her beautiful eyes.

ANNABEL'S TIPS

Always take a white umbrella with you to keep the rain off your subject whilst reflecting the light around the face at the same time. Try a dark umbrella and look at the difference! A white umbrella not only creates beautiful light around the face, you can also get it in the pictures and it won't spoil the final result.

Children can be very difficult to photograph if they are too hot. They can become uncomfortable and irritable, which is not the right mood for being photographed! Make sure you have cool drinks with you, and try to stay in the shade.

Directing

Take the children fishing in the river with little fishing nets. They'll love looking for fish and you'll get some natural shots while they keep cool. Roll up your trousers and stand in the river with them and you'll be amazed at how much easier it is to take pictures when you're cool!

Let kids splash in the sea – this will also keep them cool.

If there is no natural water nearby, blow up a small paddling pool and let them sit in it. You don't have to get the whole pool in; shoot from above and the blue water will make a great background. Place the pool in the shade under a tree or hold a coat or towel over the child to block the sun.

» Bright clothes look great against the blue background of a swimming or paddling pool

Bethany stays cool by paddling on the steps of a pool (with her Mum right next to her out of shot for safety reasons!) while I get great shots using the blue tiles as a background.

Using a towel to block the sun is very effective, as Bethany would otherwise be squinting in the bright sunshine.

ANNABEL'S TIPS

Hot Weather

If the weather becomes too hot, take your pictures in the shade or in water!

33

Sarah holds Bethany (18 months) in the shade with the sun behind them, to create flattering, soft pictures.

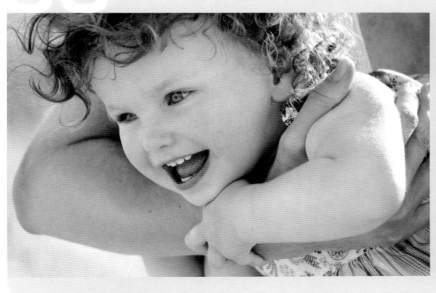

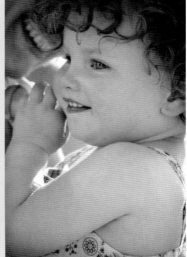

Photographing babies is quite different from photographing any other age group, because they can't walk or talk! This can be limiting but it can also be an advantage - at least they stay in one place!

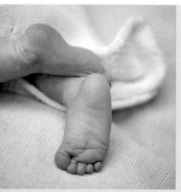

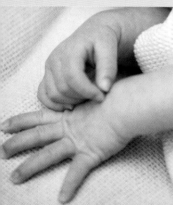

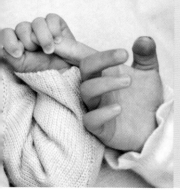

If the baby has an older sister or brother try taking a shot of both their hands together. This will show the contrast between their ages and make a beautiful piece of art which the parents will love.

Composing

Babies' toes, feet, fingers and hands are gorgeous, and every photographer should capture pictures of them for their parents. These features literally change from week to week, so getting pictures as early as possible is a wonderful experience for the baby's parents, to keep as a reminder of those first few weeks.

Directing

It is much easier to take these detail photos when the baby is asleep! You can usually carefully place their hands and feet where you want.

Babies have so many amazing expressions. Try taking lots of different face shots which will look great as a set of images all together rather than one individual photo.

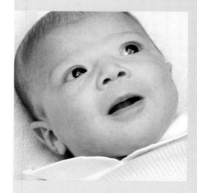

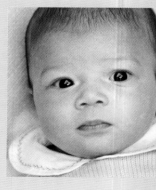

» It's not only the hands and feet that look cute!

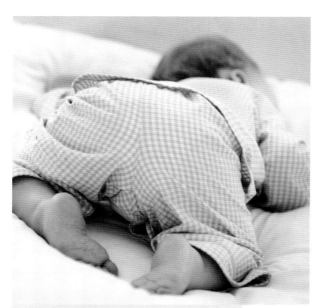

We dressed Harriet in the pyjamas we wanted to photograph her in just before her afternoon nap, then coaxed her to sleep on her parents white duvet cover, which provided the perfect background in a much lighter room than her own.

36

ANNABEL'S TIPS

Features

With babies it's not about trying to capture that one perfect smile (although it's great if you manage to do so), I'm looking to show their features, rather than the way they behave. Babies haven't developed the personality they'll have when they are 2 or 3 years old, so this is the time to photograph all the individual characteristics they are born with and which are going to change rapidly as they grow.

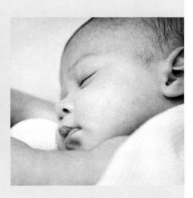

Between 18 months and 3 years most children are reluctant to be "posed" in a photograph. They get bored very quickly and just don't want to keep still! It's important to constantly change what you do, and keep them interested! If you let them just play, they'll think it's fun and enjoy being photographed.

Lighting

Set the scene, with the background you want, and the lighting soft and even (see page 20) and then just let them play, while you take candid photos.

ANNABEL'S TIPS

Candid

Try letting them play on their little car or tricycle, where they feel they're in control! You can either shoot them with the toy in shot, or you can zoom in to their faces and get some great expressions!

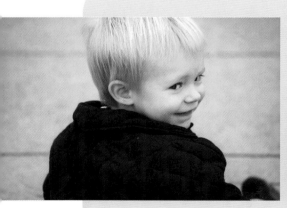

37

Allow children to play in your "scene" and follow them with a long zoom lens so that they don't really notice they are being photographed.

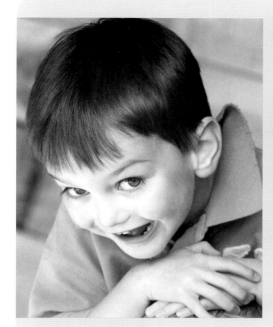

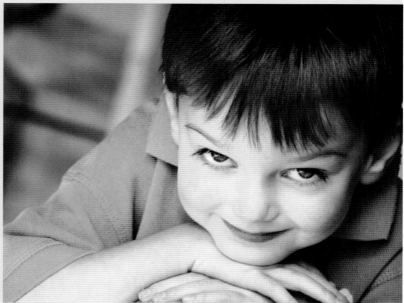

38 Putting a young child on his Dad's shoulders allows me to get great close ups at the same time.

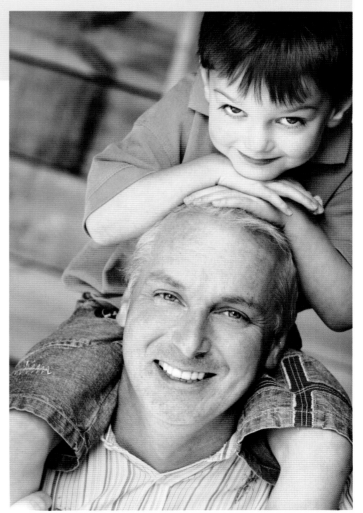

Directing

If you are finding it difficult to keep a small child in one place, try lifting them up onto Dad's shoulders. Children under 5 will really enjoy this, but if the child is under 2 make sure you're ready for the shot, as it won't be long before they want to get down!

Most young children need to be given little tasks to do to keep them interested.

Directing

Try making a cake! Young children have such a vivid imagination that ANYTHING can be put in their cake. Once you know where your background will be, stand in front of it with the child and give them a piece of wood. Put some stones/fir cones/acorns/flowers, or whatever is around you, on the ground and ask the child to make you a cake.

They will usually start stirring it all up straight away, while you keep adding more ingredients.

Then keep up a conversation with the child asking her what she is putting in her cake, and you'll be amazed at how the stones suddenly turn into apples, currants, carrots and all sorts of things!

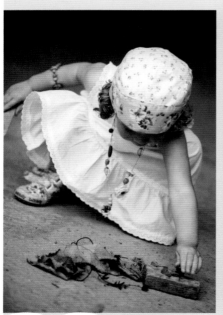

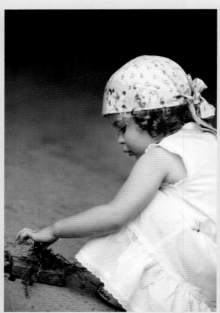

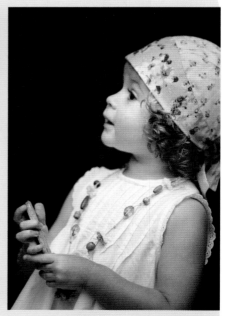

39

2-year-old Annabel collects "ingredients" for her cake while I shoot candid natural pictures

 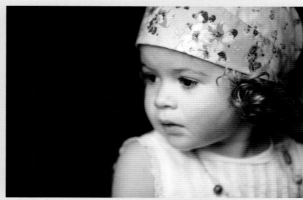

40 The "cake" doesn't have to appear in the shots; careful cropping allows me to take some great close ups while Annabel is not aware I am photographing her.

Composing

While engaging the child in conversation you can get some really natural shots of her as she plays.

TIP – **Try taking both wide and close in shots, and adjust your angle and composition while she is happily occupied.**

ANNABEL'S TIPS

Candid

To get the child to sit in one place put a piece of wood on the ground and ask her to sit on it. They usually do, but occasionally a child will deliberately refuse to do so, and if this happens, say "whatever you do, DON'T sit on that piece of wood!" and then you'll find that she will!

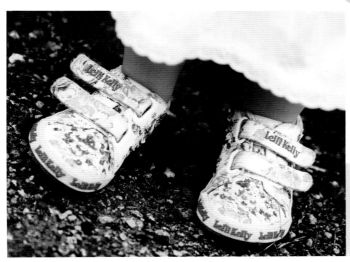

Don't forget to look for the details! Shots of a child's shoes can look great in an album as they are so small and cute!

41

Children aged between 6 and 12 are much easier to control than the under 5's. Older children need to be treated more like adults and it's important you don't talk down to them or they will not respect you.

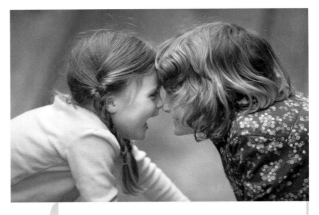

TIP 1

Ask them to face each other and then rub noses; they usually burst out laughing!

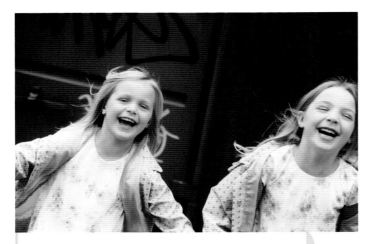

TIP 2

Ask them to run towards you holding hands – the more fun you make it and the more times you do it, the more they will laugh!

» **Older children need to be treated more like adults**

TIP 3

Ask them to play 'Ring o' Roses' and spin round together; you'll probably have to do this several times to get a good shot, and expect to bin a few blurred ones and backs of heads! But it's worth it if you get one great shot here!

Directing

It's great taking pictures of kids playing or smiling at you, but don't forget to show them interacting. Their parents will love it, especially if they look as if they are happy together when in real life they usually fight!

42 Older children are happy to be photographed particularly when you give them direction and instructions.

TIP 4

Try chatting to them about their interests, and shoot them doing their favourite things, for example with their horse, bike, football etc.

Many boys want to wear their football kits in a photo so I usually use this as a "carrot". If they do the shots their parents want first, then we can do one for them in their football kit.

TIP 5

Asking kids to hug each other will either result in them refusing or obliging and it's 50/50! You'll get a much better result near the end of the shoot, when they're really relaxed and if you achieve this kind of picture their parents will be thrilled.

Children look fantastic when they are smiling, but they can look just as beautiful when they're not! I like to take a selection of pictures which show all the different moods of childhood, from sulking, to quiet reflection, and just simply not smiling.

Shooting

Photographs should evoke emotion, and you should try to show as many moods as you can. Don't be afraid to take a shot when a child is not co-operating, often this can result in a great picture.

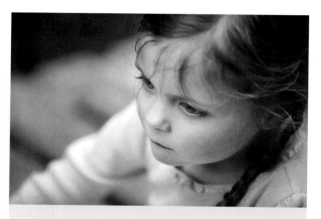

Martha does not have to look at the camera in order to look beautiful. Sometimes if you are very calm and talk in a whisper, a child will get lost in her own thoughts, and become unaware of you, which can lead to some very special pictures.

When Clay is sulking it's a great opportunity to snap those gorgeous eyelashes!

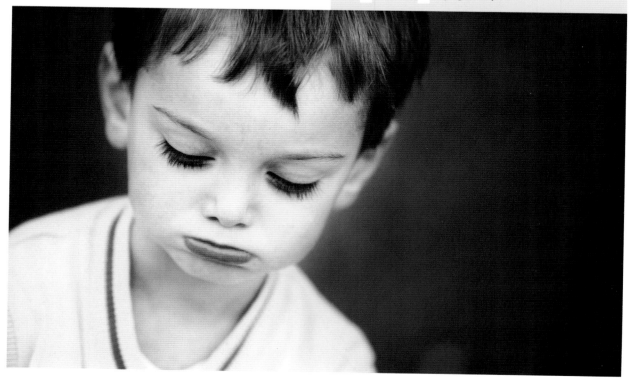

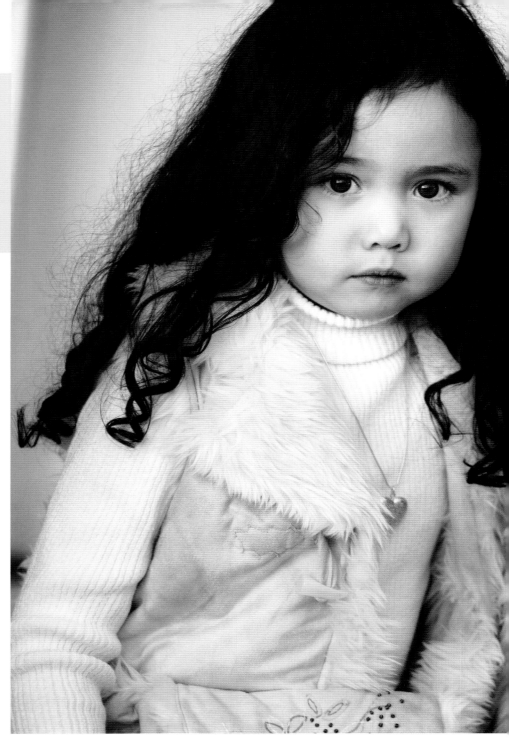

45

When children smile their eyes usually screw up, so by not smiling their eyes look bigger. In this picture, because she is not smiling, Mia's face really evokes emotion, and her features look perfect.

Composing

Let children play quietly and they will often get lost in their own little world for a few minutes; step back and shoot from a distance without talking to them at all, just keep changing your angles and composition and move around your subject, looking for different shots.

» I like to take a selection of pictures that show all the different moods of childhood

I am always asked how I get children to laugh. There are lots of ways to do this and it really depends on your own personality. Many of the people I teach have devised their own methods and they all seem to work!

Directing

Try asking parents to stand behind you and do something silly! Most parents have lots of things they already do to make their kids laugh, and it helps because the kids are familiar with them.

TIP

Don't worry about missing teeth when children are laughing – it's part of their childhood; provided you have some pictures with their mouths closed, the parents will love pictures like this as it's how their child looked at the time, and we all go through this stage!

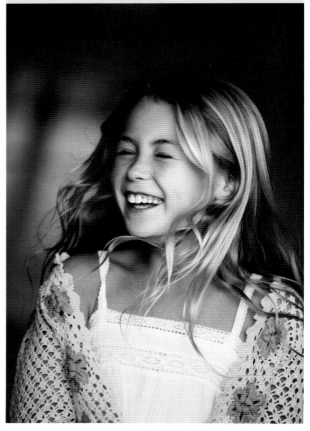

Olivia's parents are standing behind me pulling funny faces which makes her laugh perfectly!

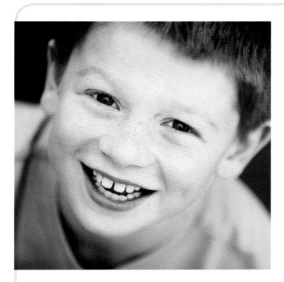
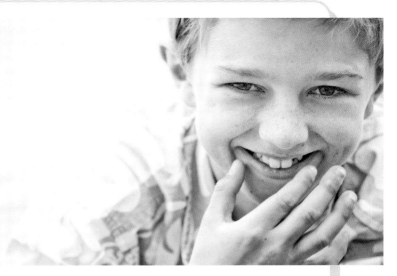

4 Ways to Get Them Laughing

TIP 1

Don't ask children to smile! This often results in a false grin, which is very unnatural. You need to get them to say things which will MAKE them smile rather than ASK them to smile to order.

TIP 2

Try asking them to say "smelly socks". Kids usually laugh when they say this because they think it is funny!

TIP 3

Keep changing the words you use; I go from "smelly socks", through to "smelly bananas" right up to "smelly bottoms" if I have to!! It may sound rude – but the ruder you are the more funny the kids think it is! Start from the least rude to the most rude, or it won't have the same effect! Do apologise to their parents at the same time! But most parents will understand that you need to get them to laugh if they are to have great pictures of their children!

TIP 4

With young children I often say: "Are you a big sausage?" and they usually find this funny; they will either burst out laughing or they will start up a banter with me and return with "no, you are!", at which I can pretend to be upset! I then move on to asking "is Mummy a big sausage?" or "am I a big sausage?", and this usually keeps them amused for a while! You can go through various foods and vegetables – whatever you can think of!

Shooting

Make sure the parent is standing up at your height, very close to you, this way the kids will keep looking up at you. It's a natural tendency for the parent to crouch down to the child's height, but this will result in the child looking at them rather than at you. (Note: I am always shooting from a higher position than the child's height – see p 76).

» Say things to get kids to laugh rather than ask them to smile to order

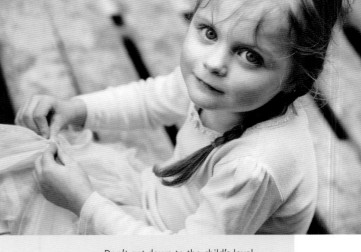

It's important to change your composition constantly to create a variety of different images, and make your pictures more exciting.

Shooting

» Try shooting both vertically and horizontally.
» Shoot some of your pictures on a slight angle
» Shoot down on people it makes their eyes look bigger.

47

Don't get down to the child's level, despite what the old photography rules say! Shooting people from above makes their eyes look bigger and the result is much more flattering.

48

If the child is not looking at you, try shooting from below like this for an interesting angle. I loved Hamish's boots and wanted to emphasise them in this picture by focusing on the boots rather than Hamish.

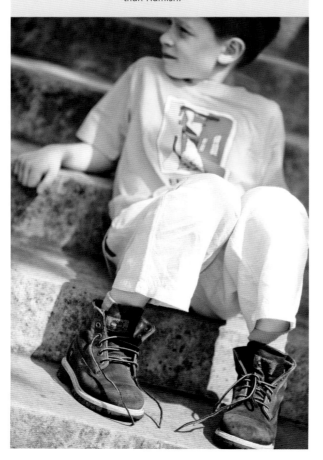

Composing

Change the kids' expressions as you change your composition, and don't always have them looking at you.

Cropping

Don't be afraid to crop in tighter and lose part of the head to emphasise their features.

» Shooting people from above makes their eyes look bigger

In this picture the crates in the background are actually straight, but by tilting the camera slightly to the left a more dynamic image is created, but hardly affects the actual subjects. Try taking a straight shot and then a slightly tilted shot, and compare the two – you will be amazed at how much more interesting the tilted shot is.

Zoom in tighter and ask the boys to look at their parents to create a totally different look in seconds!

Turn the camera horizontally and convert the image to black & white later to add more variety to your shots.

From about the age of 7 or 8 many children aspire to look and behave like people older than themselves. Twenty years ago when I first started photographing children, I would often struggle to get boys to spend more than 10 minutes being photographed! Now they spend most of the shoot choosing what clothes to wear and styling their hair!

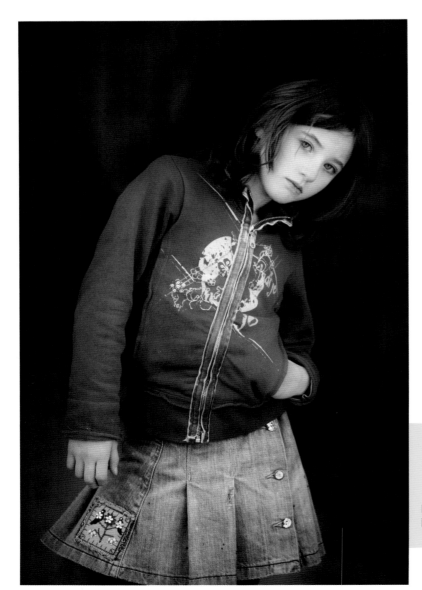

50

Poppy is only 7, but this image makes her feel like a teenager.

Clothes

Most 10-year-old girls will not wear traditional dresses in a shoot; they prefer to wear the latest fashion and want to be treated like models. It's very important as a professional photographer to respect this and keep up with the trends, in order to keep your pictures contemporary.

Big words and logos on clothes used to be frowned upon in pictures, but now they look great, and you would struggle to find clothes without labels on today anyway. Be aware that this may change in the next few years – you need to keep your eyes open and adapt and reinvent yourself constantly.

Directing

Many people would ask why I would take pictures of Poppy that make her look older, but it's all part of developing a relationship with your subject and getting the results you want to achieve. If you allow them to look as they want to look, then it's much easier to get the "smiley young child" pictures as well, because they are much more likely to cooperate with you if they think you are on their wavelength.

By changing her head position and asking her for a slight smile, suddenly Poppy becomes a little girl again!

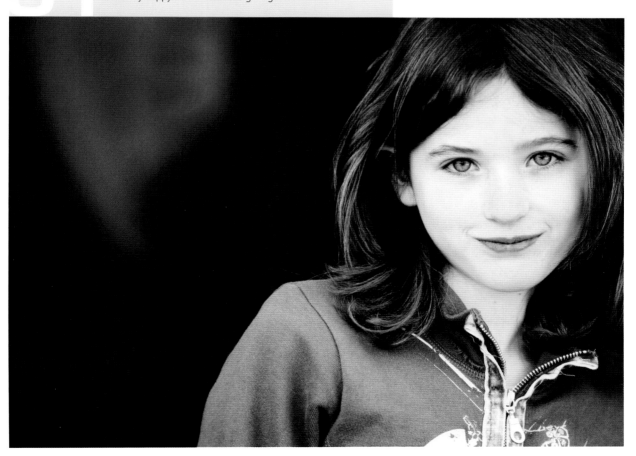

If you treat teenagers as models you will gain far more respect from them and they will be keen to do what you want if they think they will look like the people they want to emulate in music DVD's and magazines.

Many younger teenagers are very self conscious and uncomfortable with their self image. Showing them how good they can look in a photo does wonders for their confidence.

52

A photo like this will really please a 13-year-old because she looks moody and cool!

She will love this shot because she looks trendy, but her parents will also love it because she is happy and smiling and looks her age.

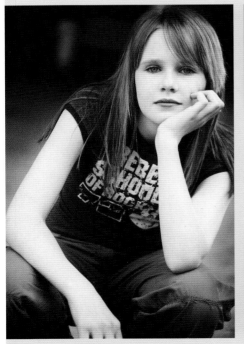

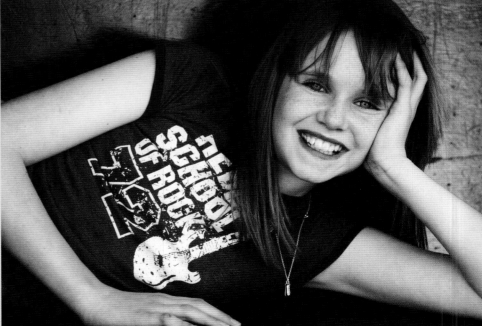

53

Let teenagers wear what they want! It's their style, so the pictures will feel much more about them!

Directing

Often with teenagers you are shooting pictures for two different audiences; for the parents and for the teenagers themselves. Most teenagers will want to look much older. 14-year-olds want to look 17, and 17-year-olds want to look 21! This can be very scary for many parents! So you need to ensure you achieve looks which satisfy both groups.

I find it is best to start with the way the teenager wants to look, to give them confidence and build up their trust in you, whilst assuring their parents that you will keep them looking like children as well!

Clothes

Teenagers want to emulate the people they see in music DVD's. Let them choose their favourite clothes, no matter what their parents think! If you let them choose their own clothes for the shoot, they will be much more cooperative, and will be happy to wear what their parents want them in later.

Look for bright colours and texture on metal doors, wagon containers, buildings etc when you are looking for backgrounds. Much more fun than grass and trees for this age group!

Backgrounds

You can find locations like these in most areas and you do not have to be in a big town or city; there are places like this in the most tiny beautiful villages, but often they are hidden away! Try going for a walk in your neighbourhood, and looking for places you've never noticed before! I can guarantee you will find disused buildings, or areas where there are wagon containers, rusty tin doors, peeling paint etc. You only need a very small area to use as a background and it's just a question of looking for it! Never be afraid to ask! The American car (top right) happened to drive into the industrial estate I was shooting in, and the owner was only too pleased to allow it to feature in the background!

ANNABEL'S DIGITAL TIP

Brighter Colours

Enhance the colours using CURVES. Try to create an 'S' shape to increase the contrast and brighten up the colours. See page 34.

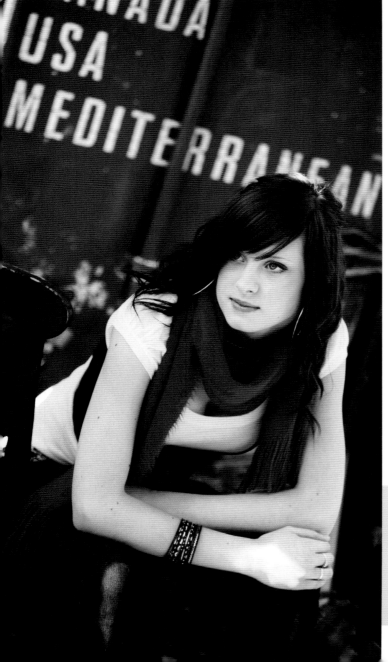

The red container behind Stephanie makes a very dramatic background and using the red scarf enhances the colour even more.

54

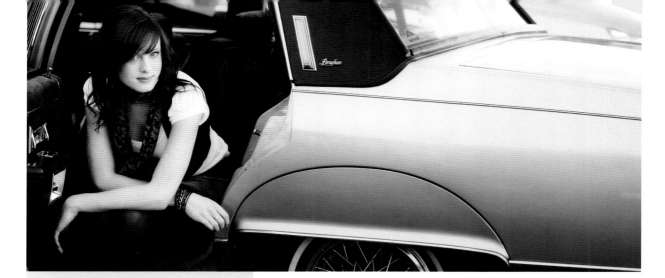

This amazing American car makes a stunning background, both inside and out.

55

This picture would have been much less dynamic if I had kept the background white, so I placed some purple garden chairs randomly into the background to introduce more colour into the image.

56

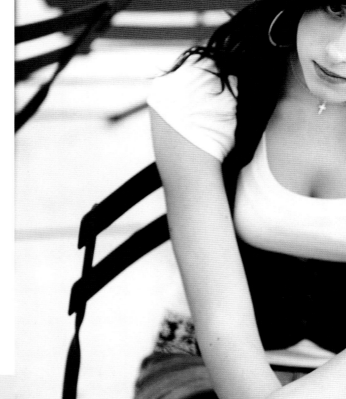

These three images all show the different effects that can be achieved just by positioning someone at a slightly different angle. In each of the pictures Sophie is lying on the ground, but by shooting from alternate angles, you can gain a completely different look.

Directing

Ask your model to lie down, and then take a series of shots from different angles. She hardly has to move for you to get a variety of different looks, and its much easier to move yourself than to move her in order to keep a sense of continuity.

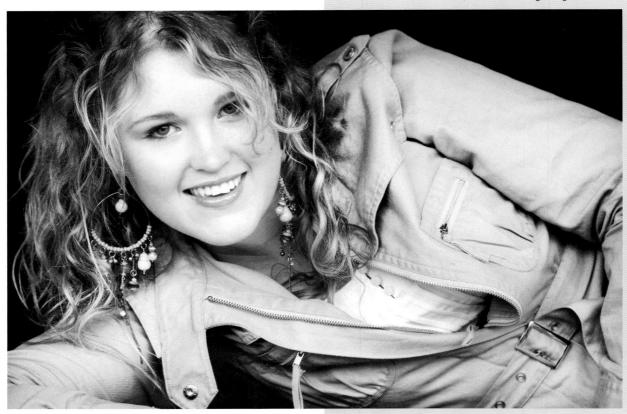

Sophie is lying sideways to the camera, which allows the whole picture to be in focus, as I am shooting straight on.

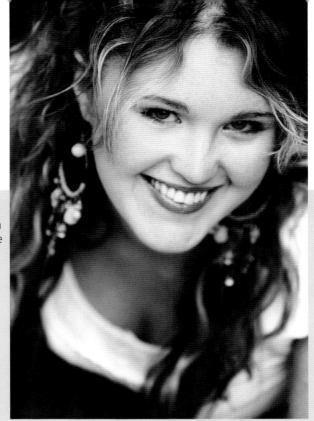

I am now shooting Sophie from the front, with her body and legs completely stretched out behind her. At F2.8 there is very little depth of field, which means her face is in focus but virtually everything else is completely out of focus, creating a very soft and dynamic image. Note how even her earrings are out of focus, which enhances the picture as they become shape and colour, rather than "earrings".

For this shot, I have moved around so that I am now looking at Sophie from a different angle, where she is lying sideways but with her legs going away from me. By setting the camera on F5.6, her face is perfectly in focus, but her body starts to go more out of focus the further away it is from the camera, creating more emphasis on her face.

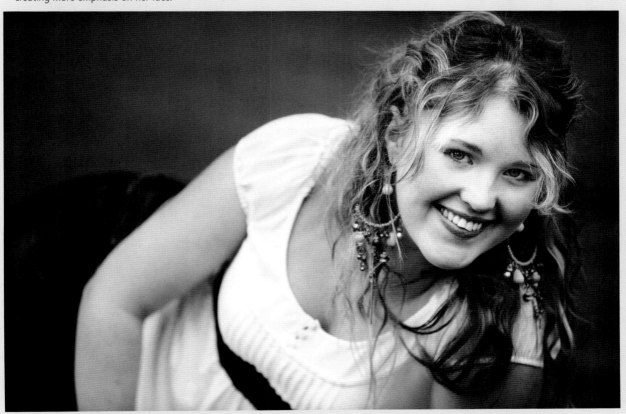

Try taking a variety of shots without moving your model! It's much easier than trying to create variety by taking each shot in a different place. It is also much easier to keep your subject relaxed, as she has very little to do except sit and look gorgeous!

Composing

Try including space on one side of the image as this creates a very contemporary feel. Many images in magazines are taken like this to create space in which to place text on one side of the page.

Place your subject off centre, and hold your camera at a slight angle. This creates a much more dynamic look than if all the lines in the picture were straight. Try it and you'll see what I mean!

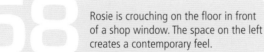

58 Rosie is crouching on the floor in front of a shop window. The space on the left creates a contemporary feel.

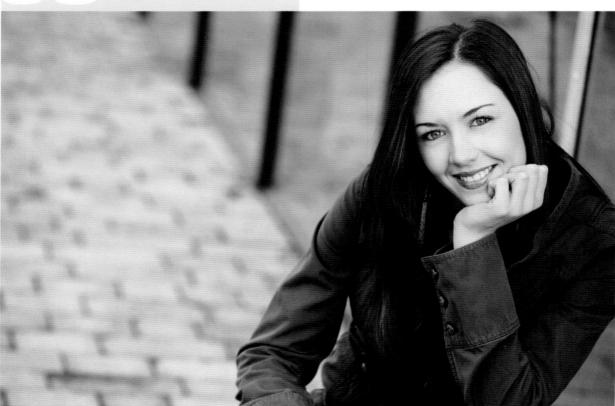

Shooting

Take shots both vertically and horizontally to change the look, and tilt her head different ways to create a variety of looks.

Digital

Changing the image to black & white makes a complete contrast, and creates more variety within the images. For techniques for converting to black and white see pages 36-37.

Changing Rosie's expression and converting the image to black & white alters the look.

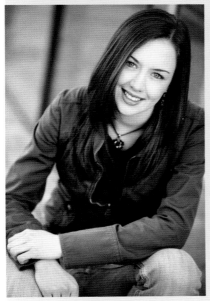

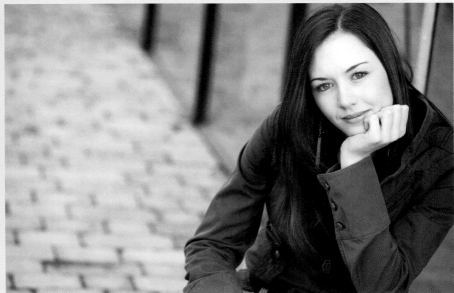

Teenagers can feel very embarrassed having their photo taken. I find the best way to photograph this age group, particularly the boys, is to try and understand how they feel and see it from their point of view. Everything at this age is embarrassing, and doing what your parents say and wearing what they want you to wear is just not cool!

Clothes

I always start by letting teenagers wear exactly what they want to wear – this way they will feel much more relaxed, as opposed to feeling very reluctant if they are made to wear something they don't feel right in. In the shots here Perry wants to wear his new football top, so I use the front porch as a background as it complements the colours perfectly.

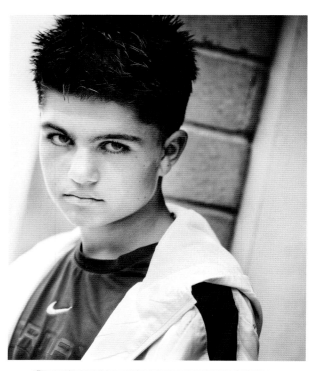

59

Start by asking him to look at the floor – something teenagers do very naturally so it won't feel difficult!

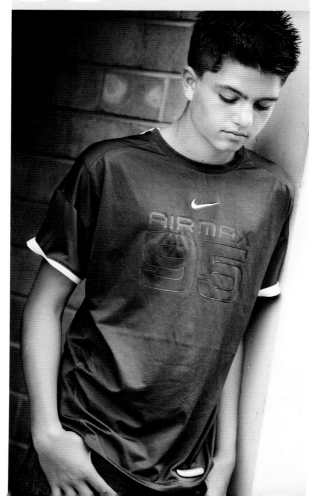

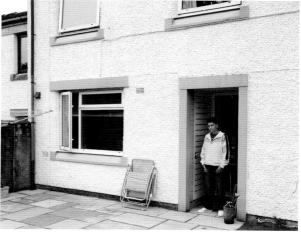

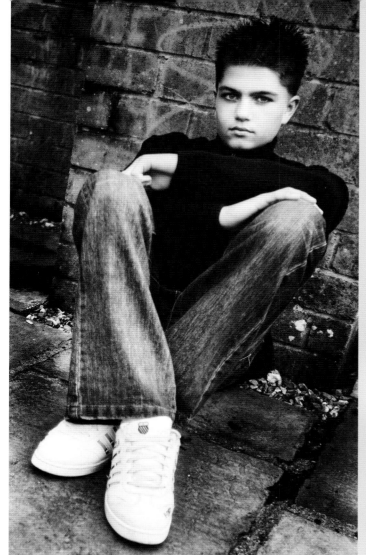

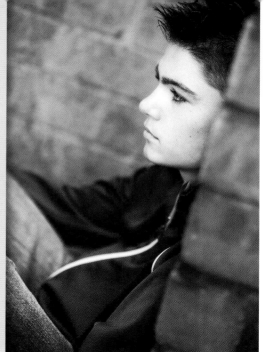

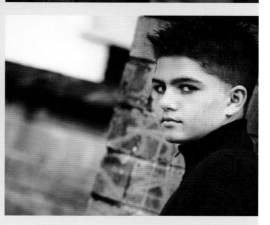

60 When your client is starting to feel relaxed because you've allowed him to be himself, then he'll be more likely to wear the jumper his Mum wants him to wear, and feel much more confident about himself because you haven't embarrassed him by asking him to do things which feel alien to him.

Backgrounds

Using bricks and texture as backgrounds gives the pictures an urban feel, entirely relating to this age group and the images they are used to seeing in magazines etc. Places like this are easy to find in most towns; these images are all shot within five yards of the front door!

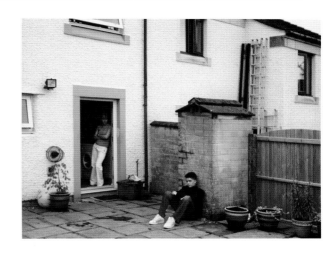

I love photographing grown ups for the simple reason that they usually hate having their photos taken! If you start to understand why, then it will be much easier to make sure they love the ones you take of them.

» Try to capture how people FEEL, not just how they LOOK

61

Natasha looks stunning in these photos because she's been given the same treatment as models usually get!

Shooting

The way I approach these shoots is to listen to what people are saying. What is it about themselves that makes them hate their pictures? Usually it's double chins and a tendency to look fatter and older than they are, and most people simply feel that it's their fault they don't 'take a good picture'.

Directing

For most adults, it's not the actual shoot they hate, it's the results they've had in the past! Many people actually like having their photo taken if they are used to seeing good pictures of themselves. However, a lot of people have had years of images they dislike, and this means that it's very hard for them to relax in pictures.

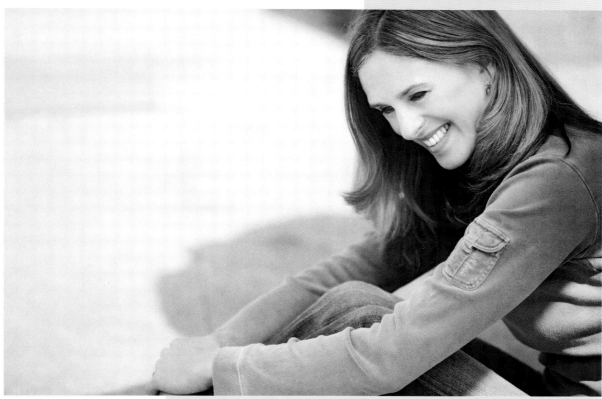

Most women love shots which look as if you just happened to walk by and take a picture without their knowledge! Psychologically, it makes them feel less vain about making a conscious decision to have their photo taken!

Confidence

Getting great pictures of women is all about confidence!
You need to give them that confidence by doing most of
your work before you ever press the shutter!

63

Try asking your subject to stand with her back to you, and
then swing her head round quickly so her hair follows her.
You may need to take several shots to get one where you
can see her face! But shots like these make the shoot a fun
experience and the client will gain confidence because she's
enjoying herself.

Directing

In order to get great pictures of grown-ups who are not models, you need to do ALL of the following things:

» Develop a relationship with your subject to gain trust and confidence through a friendly and understanding approach.
» Use soft and even lighting,
» Find carefully considered backgrounds
» Use flattering clothes
» Take control and direct people rather than ask them to 'pose'.
» Use careful positioning to hide the bits people don't like, such as tummies and double chins!
» Pay attention to detail to make sure her clothes and hair look good, and her lipstick is still in tact.

ANNABEL'S TIPS

Confidence Building

I have spent years talking to women and helping them to build their confidence through beautiful pictures. I love nothing more than the challenge of proving to people that they CAN look beautiful in a picture. The more they hate their old pictures, the more I love to prove them wrong! I believe it's my duty to take the best pictures they've ever had taken, and this is how to do it!

Grown-ups need to have trust and confidence in you. They need to feel relaxed and at ease in order for you to get good pictures of them.

Shooting

If at all possible, always start a shoot in the subject's own home. Why?

» It's familiar to them and therefore more relaxing.

» They have all their clothes to hand, so you will have more choice.

» You can understand them and their lifestyle more easily as you are surrounded by their taste, and favourite things.

Directing

Once you have established a relationship, you can move to different locations, but at first it's much easier to gain an understanding of someone's life and personality with their belongings around them.

Move to other locations once they are relaxed and getting into the shoot. Why?

» Because after a while people get bored with their own surroundings.

» They will feel re-energised and inspired in each new location.

» New backgrounds will give you more variety for your shots.

Tom starts his shoot by sitting in the familiar surroundings of his kitchen, which helps to him to relax and realise that it's going to be much easier than he thought.

64

ADULTS

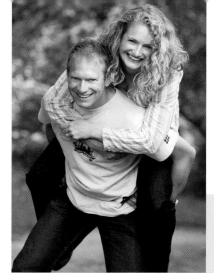

Now Tom and Laura are much more relaxed, we can move outside and inject more energy and fun into the shots!

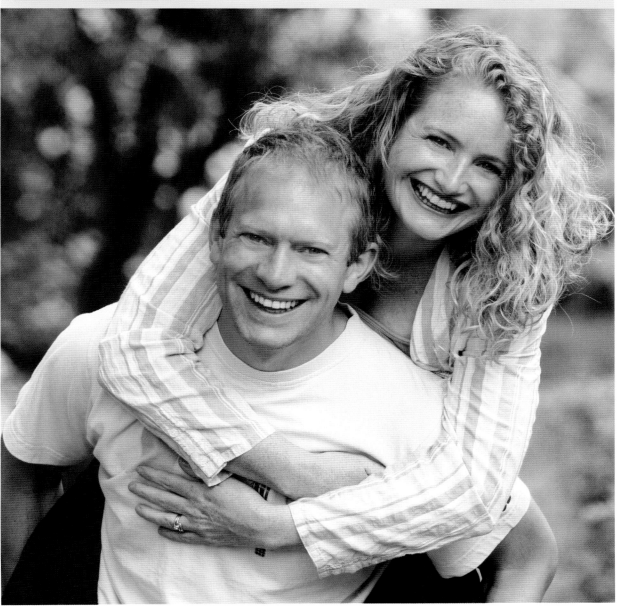

Lighting for grown ups has to be flattering. Unflattering light will show up lines and details they would prefer not to see! Shadowy lighting is very aging for most people, despite what all the old photography rules say! I prefer to find soft and even light and then move the person's face to the most flattering position, rather than move lights around to try and flatter the face.

Lighting

The opportunities for great light and backgrounds outside are endless, and you can quickly become motivated by finding all sorts of new inspiration while you are out on location at so many different homes.

One of the most flattering areas for photographs is in the light of a doorway or under some kind of top shade. On dark days you can use a reflector if you like, but if you expose correctly for the face you don't usually need one (see page 15).

Harsh sunlight does not work for adults unless they naturally look like a model. Most people look much better in soft even light because bright sunlight will tend to emphasis lines and wrinkles in much the same way as a direct flash on camera will.

» Take your subject to the light, not the light to the subject

Catherine & Simon are just inside the building, and the light is being shaded by the roof, which creates the most beautiful flattering light, without the need for flash or reflectors

66

Look for colour and texture again! Plain backgrounds will look boring. With adults I like to create a picture where the out of focus background has enough interest to enhance the picture as a whole, while still keeping the emphasis on the subject.

67

Dean and Jo are sitting very close to the shed and therefore it is much more in focus, even though the image is shot at F2.8. As the shed and fence go into the distance the more out of focus they become. Note the brightly coloured clothes that have been chosen to contrast with the colours of the seaside buildings.

68

As they run away from the background, the building becomes more out of focus creating interesting shape and texture and placing emphasis on the couple.

ADULTS

Dean and Jo are now wearing much softer, more muted colours which blend beautifully with the colours of the sand and sea. Placing them a long way away from the background throws it completely out of focus, and tilting the camera creates a more dynamic feel.

69

Backgrounds

Colours and textures create fantastic areas with which to work with. The further away from the background, the more out of focus, and the more interesting they become.

Grown-ups of any age can look great against these backgrounds! This is an advertising poster in Amsterdam, which, when out of focus, makes a great picture. David is standing about 15 metres from the poster, with a busy road in between, in order to get as much background in as possible.

Backgrounds: Be Creative

Finding the right background is fun and creative, look for what is around you and you will be amazed at the variety of fantastic backgrounds.

Yellow metal doors in a factory form an attractive background.

TIP

Rosie is lying on an old wooden pallet on a concrete floor.

Here the background is an advert on the back of a cycle transporter.

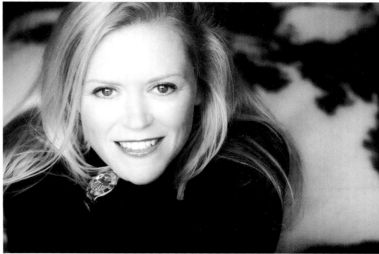

TIP

Julie is sitting on the floor in front of a cow hide sofa, which creates amazing patterns in the background.

73

Georgina is leaning against a shop window, and her reflection in the glass makes a really different background!

74

James and Laura are sitting in a bus stop!

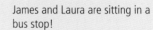

Clothes can make a big difference to a picture. Try to choose clothes which are flattering and not too tight. Choose long sleeves to take attention to the face rather than the arms, if the shot is close up. If the shot is full length it is essential that the clothes flatter the subject.

ANNABEL'S TIPS

Looking at Detail

Clothes can look very different in pictures to how they do in real life. In a close up picture you only need a hint of colour, rather than the whole outfit.

Laura's beautiful hair would be lost against her skin, if she wasn't wearing her cardigan, but the open weave allows her skin to show through without spoiling the effect.

If Laura wasn't wearing the cardigan the picture would have too much skin colour in it. This cardigan actually emphasises her face and hair by allowing the black to contrast with the blonde.

Try to find clothes that flatter people. Find long sleeved shirts and cardigans to cover up too much skin which would otherwise show in the picture and take away the emphasis from the face. Even if someone has very slim muscular arms, they will not look good at the front of a shot.

TIP

Julie is very slim and it is easy to take good shots of her, but most people with a bit more weight would be very flattered if they sat on the floor like this, positioning their arm over their knee in front of their body.

TIP

Phil could wear any top and still look slim, but a dark jacket over a V necked lighter top will make the body shape appear narrower.

76

Long sleeves which are pushed up slightly from the wrist will make arms appear longer.

77

V necks will elongate the neck and therefore make the person appear taller and slimmer than if they wear a round or high-necked top.

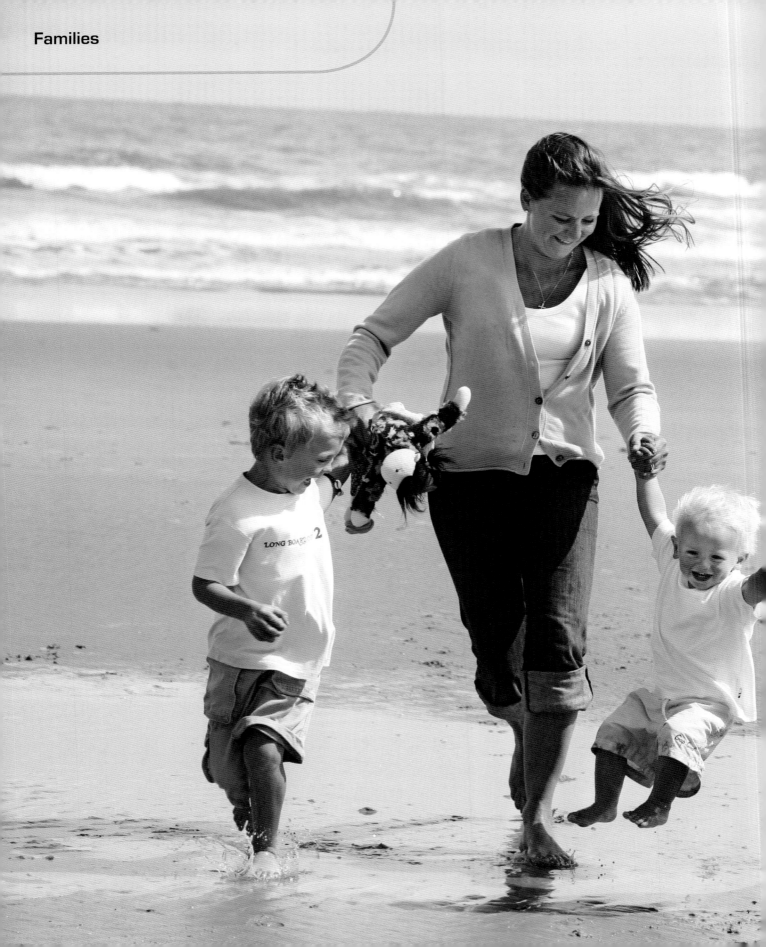

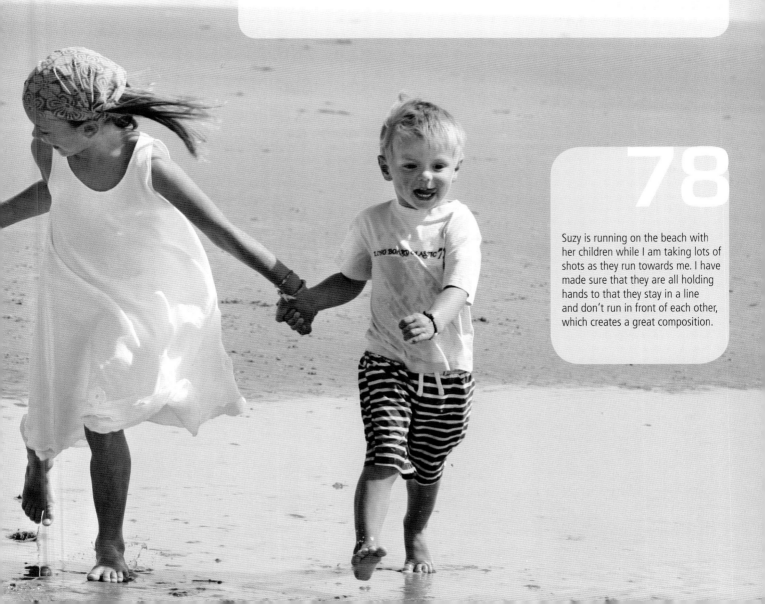

Today's parents are busy people with busy lives, and they don't often have the chance to have a family photo taken together. Usually, one of the parents is taking the picture, so very rarely do they actually have both parents in the shot.

Most adults are nervous about being in the pictures, and often say they just want the children photographing, but if you can get some good family shots at the same time, they will be thrilled.

This section of the book will give you lots of ideas for all sorts of family shots, including either one or two parents, brothers and sisters.

78

Suzy is running on the beach with her children while I am taking lots of shots as they run towards me. I have made sure that they are all holding hands to that they stay in a line and don't run in front of each other, which creates a great composition.

Photographing a family can be quite daunting if you've never done it before! It requires a lot of organisation and open mindedness, particularly if there are a lot of people involved in the shoot.

Shooting

Your best results will come from getting yourself in the right "zone". Don't take yourself too seriously, and expect huge things from each shoot – this will set you up to fail. If you go on a family shoot in a good mood, with an open mind and determination to thoroughly enjoy yourself – you will get much better pictures – trust me!

ANNABEL'S TIPS

1 Give yourself time to get to know the family; have a coffee with them first and develop a relationship

2 Leave your cameras in the car until you've achieved number 1!

3 Find out about what they like doing together as a family. Do they play in the park? Do they go fishing? Do they have bikes?

4 Select your backgrounds before you start the shoot, so you know where you are going next and don't run out of ideas.

5 Select the clothes for each background before you start the shoot, so you have more choice about which clothes will suit each background.

6 Choose some fun clothes for the last shoot, such as ballet tutus or football strips.

» Just go with the flow and you'll find it works much better than worrying about it all!

79

Try to place the adults in the centre and then bring in the children, to give a good shape to the overall shot. The picture above is composed to flatter the adults and show us what they "look like", whereas the picture below places their heads closer together to give more intimacy and create a more interactive picture.

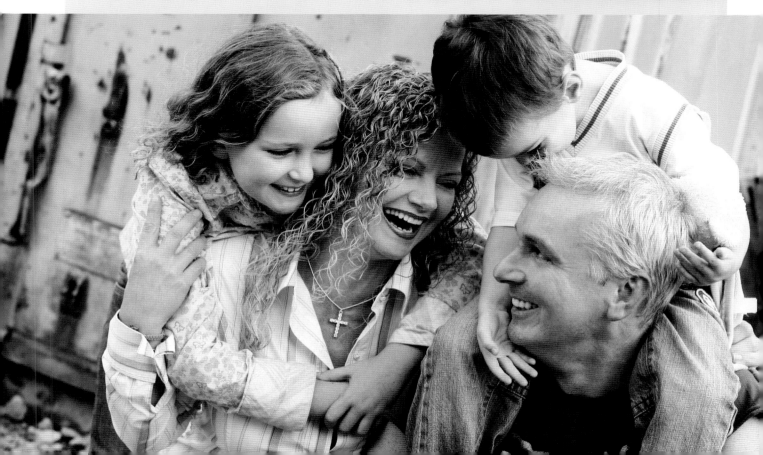

I don't like to check out the location before I do a shoot, because if I do, I feel I've done the shoot already! I like to arrive on the day and be inspired by what I see, as I find it makes the shoot much more creative. Usually there will either be too many places to take photos or not enough and either way, it makes it a challenge. Creative people thrive on challenges; it makes it all so much more fun!

ANNABEL'S TIPS

Limit Your Choice

If there are too many places you will be spoilt for choice, but my advice is to select 3 or 4 backgrounds and stick to them, so that you can concentrate on getting great pictures of the family and children, rather than lots of pictures of different backgrounds.

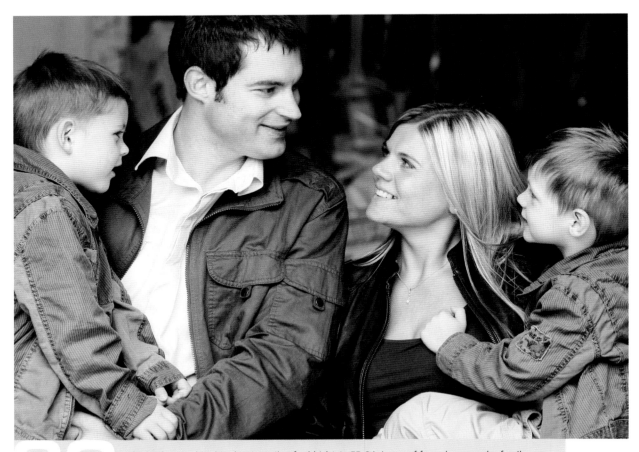

The background in this shot is a pile of rubbish! At F5.6 it is out of focus because the family are about 2 metres away, but because they are all in a line and close together, their faces are still in focus.

80

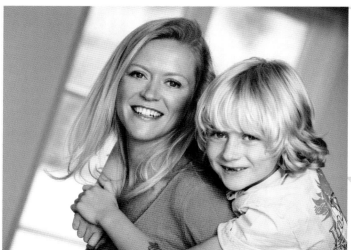

TIP

This picture is taken in a room which has windows on both sides, which enabled me to light their faces from the window behind me. The camera is angled to put the background on a slant and therefore emphasise their faces.

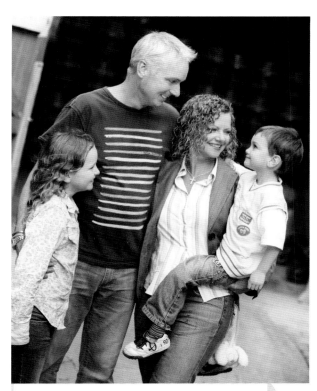

TIP

This background is made up of a stack of beer barrels in a brewery, which when out of focus creates great shapes and textures.

The blues of the metal in the background look great with Nigel and Rocco's blue clothes

Starting your shoot in a doorway means you can contain younger children, allow people to feel "safe", and get your safety shots in the perfect light, before you go out into the big wide world!

Shooting

Starting the shoot in the doorway allows the family to group together and feel secure, as they are just sitting or lying on the floor in a small space which also helps to contain the children! Once you get into the garden or onto the beach, you may not be able to keep them all in one place, so I like to take some 'safety shots' first.

Lighting

The doorway also creates a soft, even and therefore flattering light, which is very important when there are adults in the shot, as mixed lighting will highlight any lines and areas adults don't want to see!

Julie is sitting on the floor, while Olivia sits beside her and Harry kneels just behind her and puts his arms round her neck. This gives the shot a 'cuddly' feel, rather than just placing everyone besides each other in a line.

Background:
Cow skin sofa turned round and pulled into the patio doorway.

Dawn and Richard are holding Harriet between them so that I can get a nice shot of the whole family close up. Lying the adults on the floor means I can get Harriet's head at the same level when she sits down.

Background: Hall floor in the front doorway.

83

Claire is lying on the floor while her daughter sits on top of her and puts her arms around her neck.

Background: Doorway of a wooden garden shed.

84

Try to include shots which show families relating to each other. Most people want a photo where they are looking at the camera, but they also love shots which show them interacting with their children.

Composing

Well composed, natural shots do not usually just happen. You need to set them up first and then make them happen, otherwise you may have the back of the child's head in shot, or not be able to see Mum's face properly when you ask them to tickle each other.

ANNABEL'S TIPS

1 *Set up the first shot so that your subjects are looking at you, then ask them to do something which will make them interact, such as Mum tickling her child.*

2 *Try to keep their heads close together on the first shot, by asking Mum to lean towards her child.*

3 *Saying to the child 'can you give Mummy a cuddle?' often results in a great shot.*

4 *Asking them to rub noses often results in them bursting out laughing.*

85

Parents love pictures which show them interacting with their children.

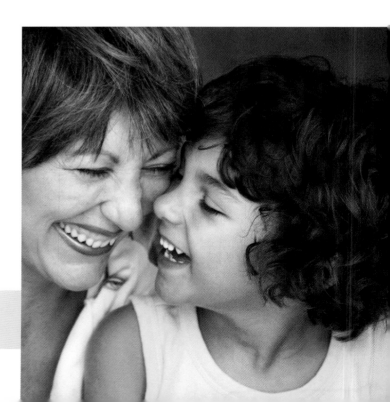

86

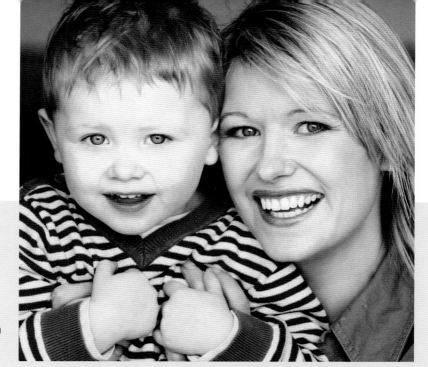

Yvette is sitting on the floor, with her little boy standing beside her. She then holds him towards her and leans her head on him to bring their faces together for the shot.

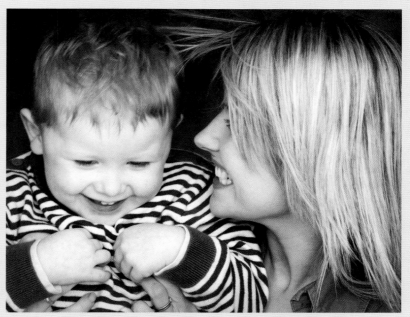

I asked Yvette to tickle her little boy and then took several shots. Because I have set up the shot first, their faces stay relatively close, allowing me to get a great composition.

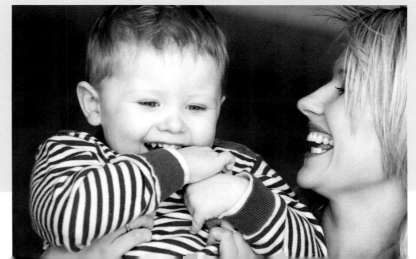

Family Groups

It is easier to group several people together if you position them on steps or a gate, where you can use the different levels to bring their faces closer together.

87

Here I have asked the family to sit on some steps. By placing the parents in the centre of the picture first, I can then arrange the children around them to bring them closer together, rather than just asking them all to sit in a line.

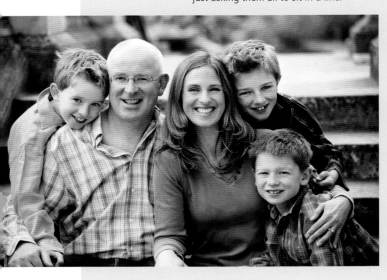

» With smaller children, try placing them on Dad's shoulders, which may contain them for a few minutes

Once the family shot has been set up, I then say 'all give each other a cuddle' and the resulting shot is usually then more intimate.

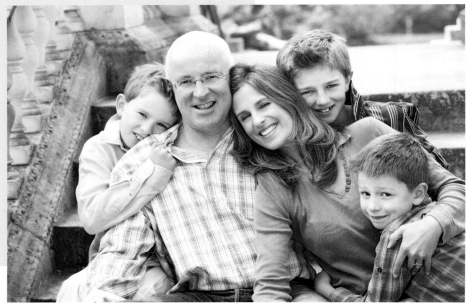

FAMILIES

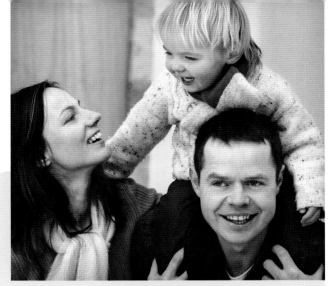

ANNABEL'S TIPS

Crouch Down

Crouch Dad down, and then ask Mum to crouch to the side facing towards Dad. Then put the child on Dad's shoulders and shoot away!

Angus thinks it's fun to be up high on Dad's shoulders, and with Mum positioned at the side she can talk to him, and we can create an image which looks very natural. If Dad had been standing up, the shot would not have been as successful because I would be looking up at them, whereas being able to look down on them makes a more flattering image.

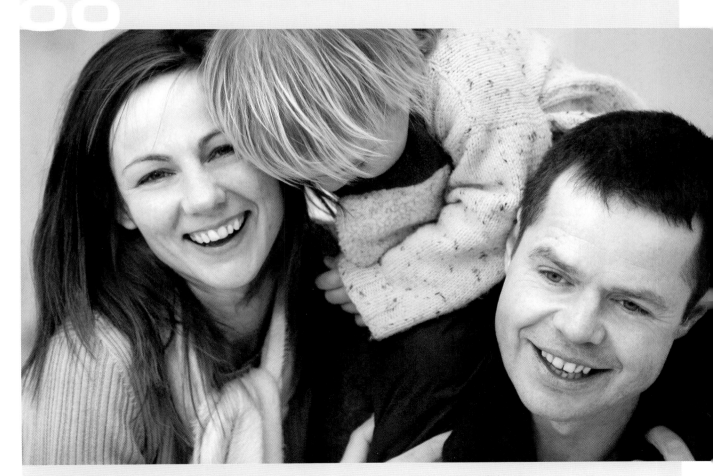

Even though Angus is starting to get bored, I can still get good shots which are very natural because while his parents are trying to control him I can get some great expressions! Because they were positioned well in the first place, whatever happens, I am likely to get some well composed shots.

Occasionally parents will say they don't want to be in the pictures. However, if you tell them they will be out of focus they are often quite happy to participate!

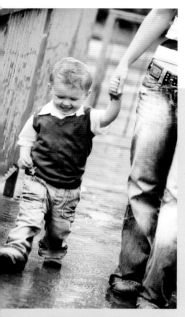

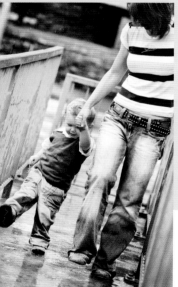

This image works well because the emphasis is on the child as only his Mum's legs are included in the shot.

In this shot we can see more of Liz, but as her face is hidden by her hair, the emphasis is definitely on Eli, which makes her feel less vulnerable. If a parent is shy about being in the picture, assure them that you are only getting her legs in the shot, and then she will feel more confident.

» Parents don't always want to be in the pictures!

Shooting

If you are shooting on F2.8 you will be able to focus on the child's face and the parents will become a soft blur in the background which can be extremely effective. Most parents love this kind of shot where the child is the main subject but they are still included in the picture.

The parents are well out of focus in this shot because the child is about 1.5 metres away from them with the camera set on F2.8.

91

Here Justin and William will feel less self conscious because I have asked them both to look at Fleur and James who are standing out of shot.

Directing

Try placing the parents together, sitting down with the child and then either call the child towards you, or put something on the ground near you that will attract their attention and such as leaves or flowers, or their favourite toy

92

In this shot Kim is only slightly out of focus because Jack is only about half a metre away from her with the camera set on F2.8.

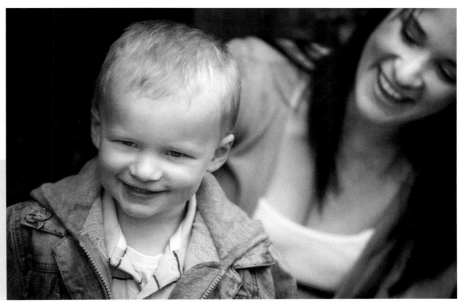

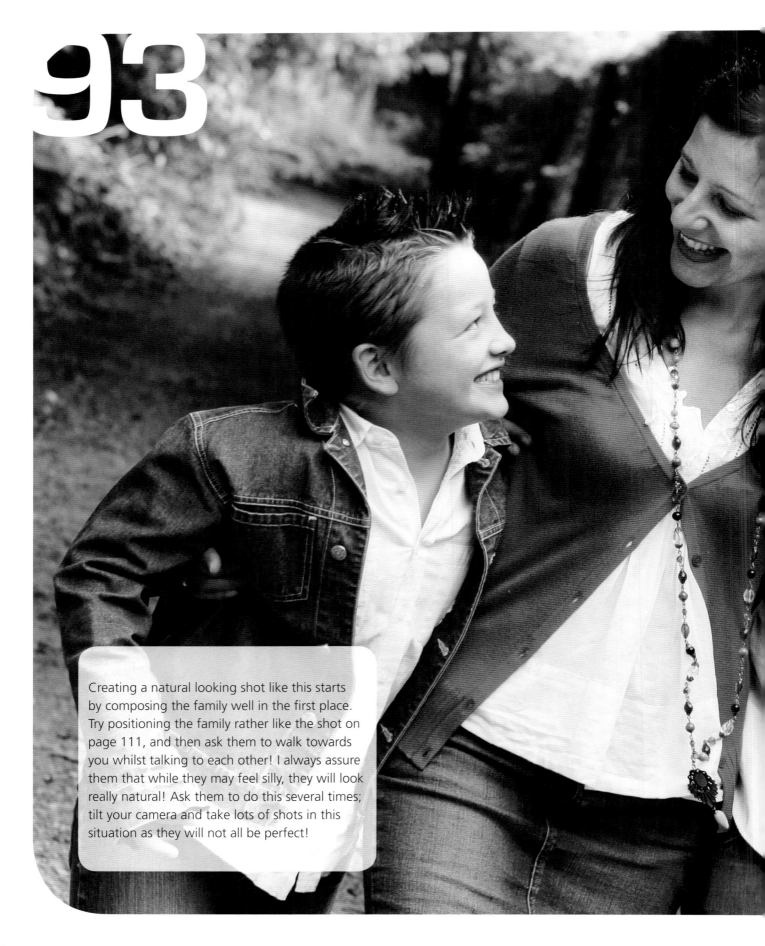

93

Creating a natural looking shot like this starts by composing the family well in the first place. Try positioning the family rather like the shot on page 111, and then ask them to walk towards you whilst talking to each other! I always assure them that while they may feel silly, they will look really natural! Ask them to do this several times; tilt your camera and take lots of shots in this situation as they will not all be perfect!

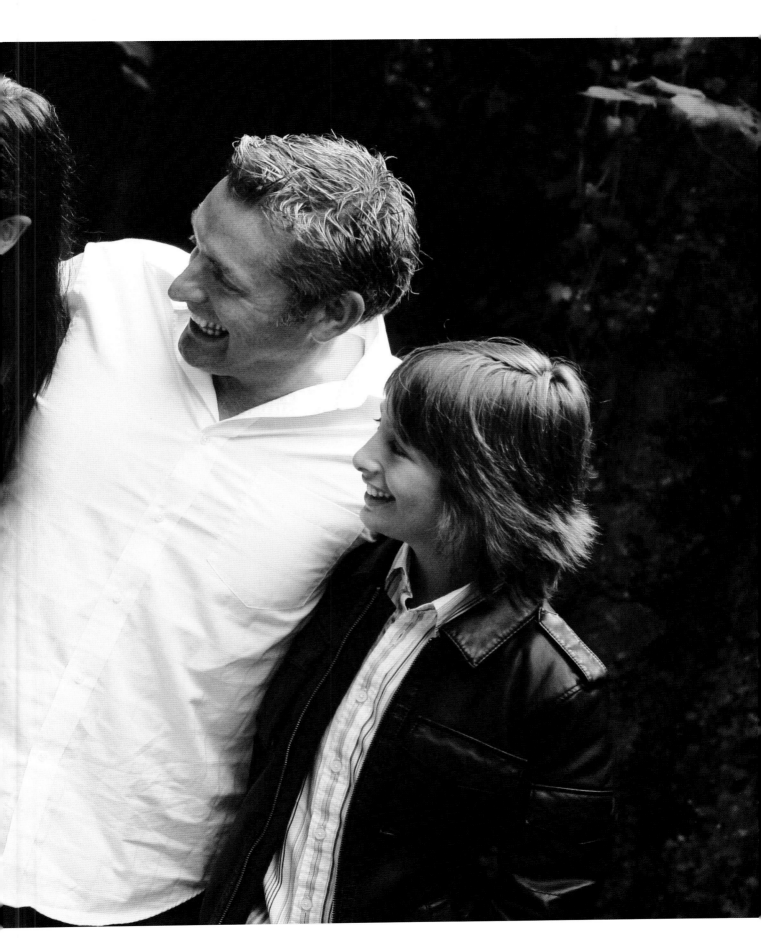

Here are lots of ideas for great family shots!

Directing

Little children love being swung in the air between their parents, and if you only include the parents' hands, it makes a great shot which will look really good as a canvas block on the wall later.

Often the best shot is taken while the child is **WAITING** to be swung. If you say: 'Are you ready? Are you ready?' you will often find they stand still and smile while they are waiting with anticipation.

Charlie is waiting in anticipation, to be 'swung' and is smiling as I ask him if he's ready.

Most children will laugh really hard when they are being swung, resulting in a great shot.

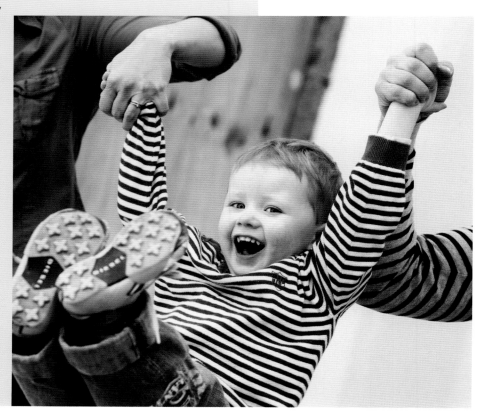

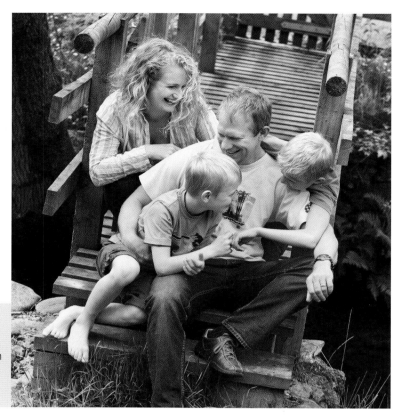

95 Try sitting the family down and then asking them to tickle each other; this often creates mayhem and some great pictures!

96 Say something like 'Has Daddy got a spider on his nose?' and the child will usually look and laugh

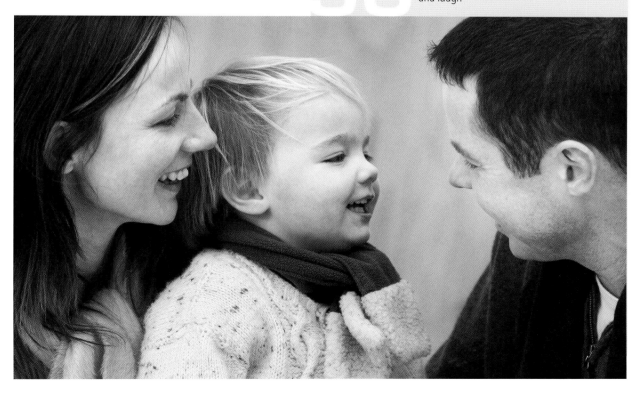

97 Position Mum and daughter together so their faces are close, then ask them to rub noses; often resulting in a shot that looks very natural even though it has actually been carefully set up.

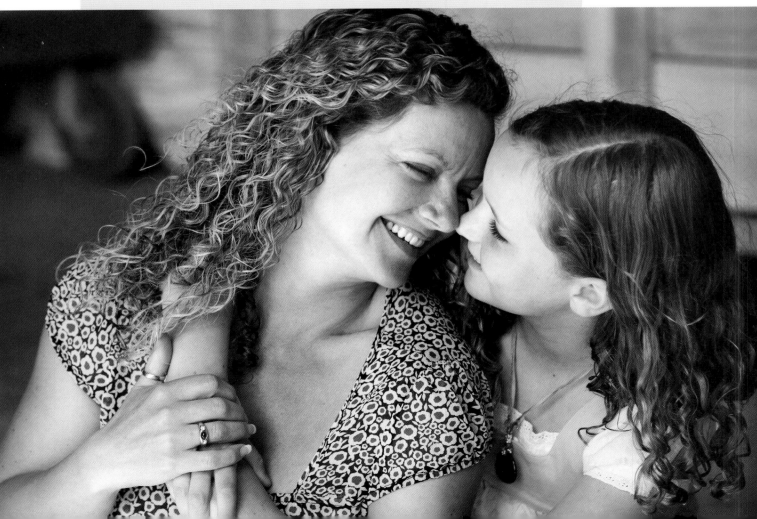

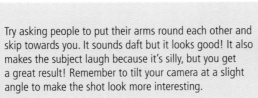

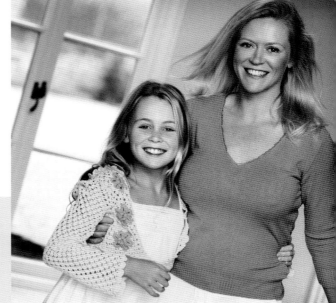

Julie is giving Harry a "piggy back", which is a great way to make people laugh. Note, if you are shooting on F5.6 to keep the background OUT of focus, then you need to keep your subjects' faces close together to keep them IN focus. This works best if you turn them sideways rather than have them facing you, otherwise the person behind will be out of focus.

Then I asked Julie to turn her head and look at Harry, which creates the interactive shot.

98

ANNABEL'S TIPS

Separate Shots

Try to take separate shots of the parents and children as well; it's easier than taking them all together and it means a lot to each individual child that you are treating them as an individual and not always as siblings.

99

Try asking people to put their arms round each other and skip towards you. It sounds daft but it looks good! It also makes the subject laugh because it's silly, but you get a great result! Remember to tilt your camera at a slight angle to make the shot look more interesting.

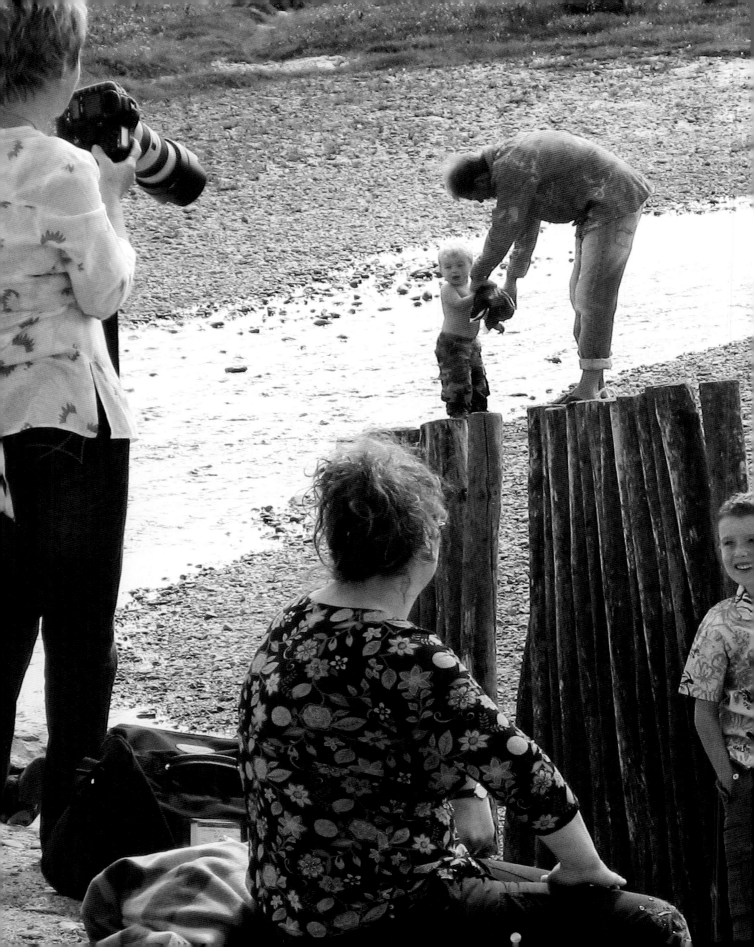

In the Doorway

Today's shoot is of a family with two young boys, who live within 20 minutes of a beach. The beach is however full of grass and the water is miles away! But we have plenty of scope for pictures of the two boys playing in an environment they often visit.

» Karen, the make up artist/stylist is on hand to put any stray hairs back into place, and make the adults feel their best.

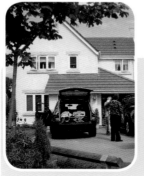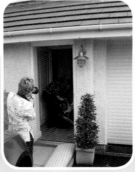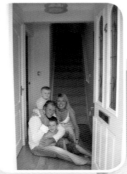

STEP 1 – Here, I have removed the door mat, and positioned the family very close together in the small hallway, which gives me a very flattering light. Using F5.6 and leaning their faces together ensures they are all in focus but the stairs in the background are not as sharp.

» I start my shoot with my "safety" shots which are taken in the front doorway, to ensure I can keep the younger child in one place.

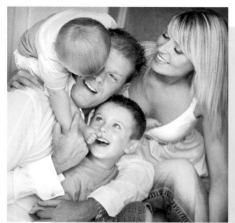

STEP 2 – As you can see the light is beautiful on the resulting shot, and you'd never know it was taken in a doorway!

It's also a great place to take individual shots of the boys before I lose them on the beach!

» On the beach the boys instantly want to run to the place they always play – a little channel of water where they love throwing stones.

Off to the Beach

Once we've got our safety shots, then we jump in our cars and go to the beach, remembering to pack spare clothes, drinks and snacks just in case the boys get fed up and need a break.

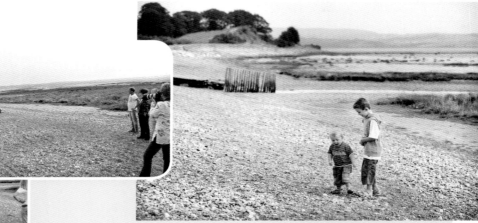

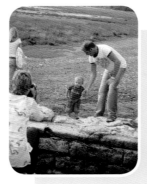

STEP 3 – First, I ask them to collect some stones, and then stand well back with my zoom lens, so that I can take pictures while they collect stones unaware of my camera. Karen and the boys' parents look on in the background.

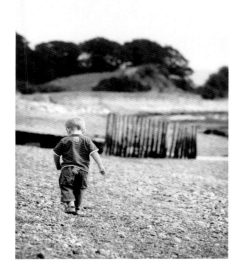

STEP 4 – Then we reach the water channel, and the boys immediately want to throw the stones in. In order to get good pictures I need some control here! I also have safety concerns! So I ask Paul to sit very close to two-year-old Harrison, and pass him stones so that Harrison doesn't keep wandering off and remains in my picture! I also want him to stay close so that he can grab him if he gets too close to the edge of what is actually a one and a half metre drop!

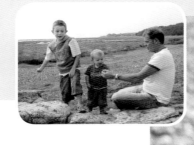

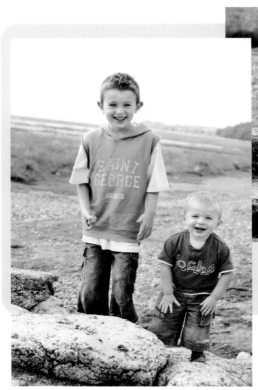

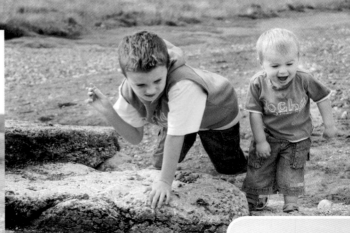

STEP 5 – I ask 9 year old Taylor to play throwing stones with his brother, so we can keep Harrison amused.

STEP 6 – I can then shoot across the channel knowing that the children are safe, and just capture them naturally as they play.

STEP 7 – Now we move closer to the water and Harrison decides he would rather be in it with the stones!

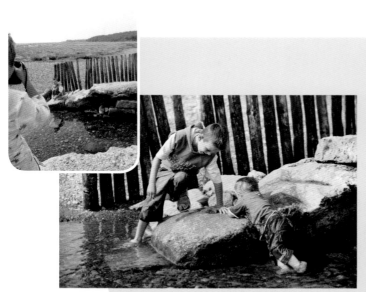

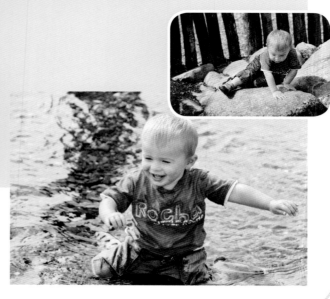

» Of course, the inevitable happens and Harrison falls in – but this just makes some great shots, as he thinks it's really good fun!

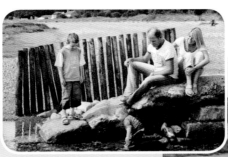

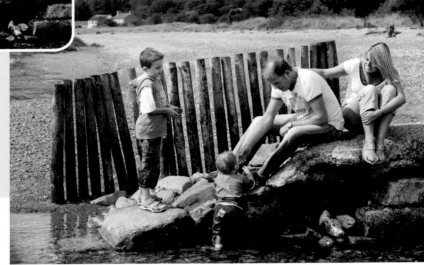

STEP 8 – Next, I ask Paul and Nina to sit down at the top of the rock, so I can get some shots which include the whole family in a situation they are often in, which will mean a lot to them in the future when they look back at these times with their young children.

» Because Harrison is soaking wet now, we decide to get the whole family wet.

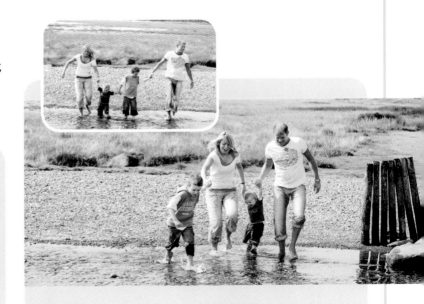

STEP 9 – First I ask them all to stand at the water's edge and hold hands together. I say "are you ready? Are you ready?" to the children, while I make them wait – it is often this moment that looks the best, because the children are full of anticipation at running through the water, and will often look at the camera and smile!

STEP 10 – Then I take a series of shots while asking them to run through the water again and again. Because they are actually running, some of these images may be blurred or the expressions may not be right – it's always a bit hit and miss when taking shots like these, so don't expect them all to be perfect – take plenty at this point and you should get some great shots out of the sequence!

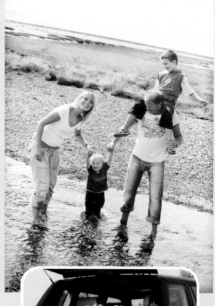

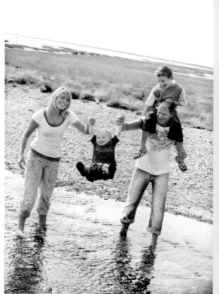

STEP 11 – Then its back to the car to change clothes! We have a little break and give the children a drink and a biscuit, so they are ready to start modelling again!

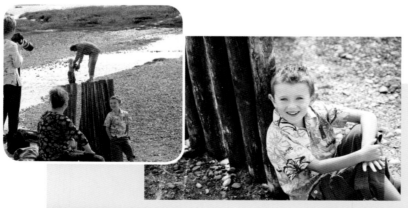

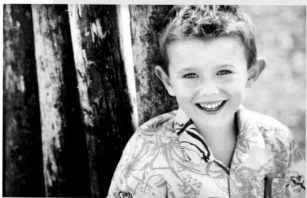

STEP 12 – This time it's Taylor's turn, and because he is older I can ask him to lean against the wooden posts, and get some great shots in his brightly coloured shirt.

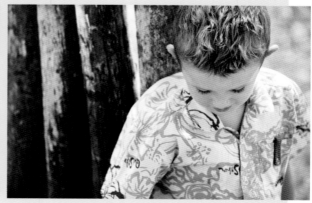

Something Different

By this time, Harrison has got cold from playing in the water so we decide to go back home and do something different!

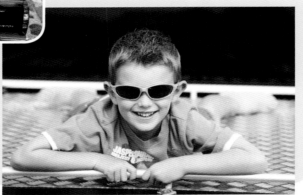

STEP 13 – I love the texture of the chequer-plate on the back of the family pick-up truck. It is a great colour and because it is so shiny, it's a built in reflector! The light is so bright, we decide to put on sunglasses to complete the look!

» Make sure an adult is nearby in case they decide to jump off!

STEP 14 – The children love being high up on the back of the car and see it as a game, so they are quite happy to have their photos taken. I love shooting from high above them as it's a much more flattering angle, so I climb through the sun roof of my car and shoot the shots from there!

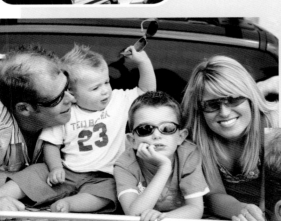

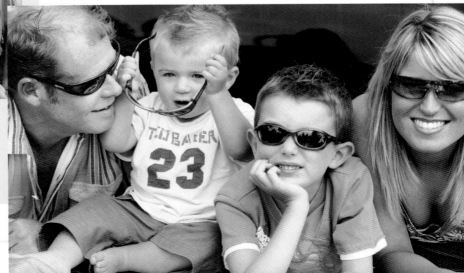

STEP 15 – Eventually Taylor asks if the whole family can join in, and Mum and Dad are only too happy to oblige!

4 WHAT SHALL I DO WITH MY PICTURES?

What Shall I Do With My Pictures?

Now you've taken all these fantastic pictures, what do you do with them? With digital cameras it is so easy to be 'snap happy' and take thousands of shots that never actually leave the camera!

This is one reason it is important to limit yourself to how many shots you take – it is much better to take a few good shots than hundreds of average shots! Think carefully about what you shoot, so you can save time later not having to trash so many.

It's often useful to think about what you might do with your shots afterwards, while you are actually taking them. If you can get into this discipline, it will pay dividends later. For example if you are shooting art for your walls, then it makes sense to think about where you want to hang a picture – what shape is the space?

» With digital cameras it is so easy to be 'snap happy' and take thousands of shots that never actually leave the camera!

ANNABEL'S DIGITAL TIP

Be Organised!

Once you finish your shoot, you will need some system of organisation for your images to avoid ending up with the digital version of storing all your old snapshots in a shoe box!

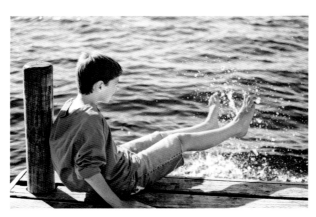

Think about what youíre shooting so you have a variety of different shots, rather than shooting lots of the same thing.

Digital

There are many pieces of software available for storing images, and it really depends on the type of photographer you are as to what you will need. If you are storing your holiday snaps then you will not need as much storage space as if you are a professional photographer.

>> If you follow the simple procedures in this chapter, you will enjoy the end result as much as you enjoyed taking the photos in the first place.

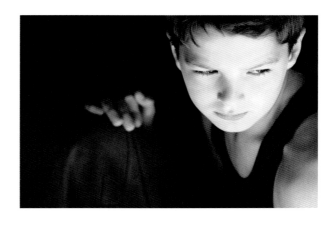

Organising your Images

Once you've set up a simple system, it will always be easy to download your images, store them, and be able to find them quickly in the future.

There are many programs you can buy that will sort and store your images for you, but I still back-up everything in the old fashioned way too! I would hate to think what would happen if my computer broke in the future, and took all my images with it! Therefore, I always store my images on to my computer hard drive, but at the same time back everything up on to a disc to store it as well.

You will require:

1. CD's or DVD's depending on the amount and resolution of images you shoot
2. A CD/DVD storage folder with numbered pages
3. An A-Z book to file names for reference and easy identification
4. An external hard drive for storage

Stage 1 – Downloading

a) When you finish your shoot download your images to your computer using the firewire supplied with your camera, or a simple card reader.

b) Back up your images to a CD or DVD before erasing your flash card, to make sure they are safe.

Stage 2 – Referencing

Enter the name of your client or shoot into your A-Z index book along with the reference number from the CD/DVD file, so that in future it is easy to look up "Greek holiday 2008" under G, find the reference number and go straight to your CD of images. As a professional photographer with thousands of images, I have everything backed up on my hard drive and can quickly find an image. But in 10 years time, it will be quicker to use the reference book and CD, rather than trawl through the many hard drives I will have amassed by then! If you are not a professional photographer, this CD system is a very easy way of finding your images.

Stage 3 – Editing

Now you have all your images safely stored you can edit them. Most cameras come with a programme for editing your images; download this to your computer and follow the instructions given by your camera manufacturer.

1 Open the browser and your images will be displayed in a similar way to the image below.
2 Delete everything that you are unlikely to use!
3 Remove all the shots that show people blinking, and all blurred shots that are not "artistically blurred"!
4 Now go back through the shots and remove any that are very similar to others. Be ruthless! Too much choice is exhausting!

ANNABEL'S DIGITAL TIP

Back Up!

Back up your images to CD/DVD before editing in case you delete one later by mistake – this saves you having to download it again from the flashcard.

Stage 4 – Enhancing

Once you have chosen the images you want to keep you can play with them to your heart's content on Photoshop or other similar programmes (see pages 32–37).

If you do not want to use Photoshop, or prefer something simpler to start with, there are many simple programmes that provide you with a choice of ways to change your pictures at the press of a button. Basic programmes like Picasa can be downloaded free from Google, and are a great way to store all your images and play with them very simply. This is the program I have on my home computer for my family to download their snapshots, and do whatever they like with them.

I tend to use iPhoto on my Apple Mac for my own holiday snaps and for my professional pictures I use Photoshop.

If you want to take up photography professionally, more sophisticated programs like Aperture (Apple) and Lightroom (Adobe) will store and enhance your images and can also link to Photoshop.

The best way is to experiment and find out which way suits you. There is no right or wrong way – only the way you find easiest and most suitable for your own needs.

ANNABEL'S DIGITAL TIP

Be Ruthless!

Delete all the bad shots! It makes your set of images much more attractive.

If you leave them in it's surprising how they weaken the whole set.

Creating an Album

It's great to see your pictures in an album, and digital albums are very easy to make.

As a professional photographer, I use very up-market albums which I have custom made for me because my products have to be absolutely stunning for my clients.

However, if I want to make up an album of my holiday snaps, then I will make them myself using iPhoto. These albums, cards and calendars are incredibly cheap and simple to make as most of the work is already done for you. You can choose hard or soft album covers, different sizes and as many pages as you like.

Simply import your finished pictures into iPhoto, and then drag and drop the pictures on to the pages, choosing the layouts as you go! It's really that simple, and is a lot of fun! There's nothing nicer than seeing your own work in print, and the quality of these albums are amazing!

They even make you think about what you shoot on holiday! Try seeing your holiday as a project and shoot pictures for your first book – you'll be amazed at how much more fun it is, when you have an end result to work towards. Instead of taking just one photograph of something, try taking 3 or 4 different angles of the same thing, so that you can place them on a page as a set of images. This will inspire you and make you more creative!

iPhoto is an Apple program provided with your Mac computer. For PC users you can download your images to various sites on the Internet, who will then make up the images for you; try www.photobox.com.

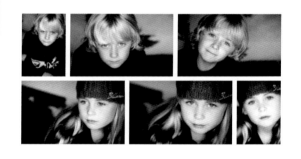

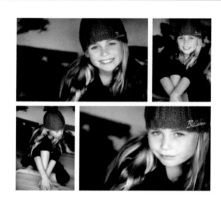

I always use top quality, custom-made albums for my clients and the pages above are taken from an album made by Queensberry.com in New Zealand who offer a full digital printing and design service for photographers all over the world.

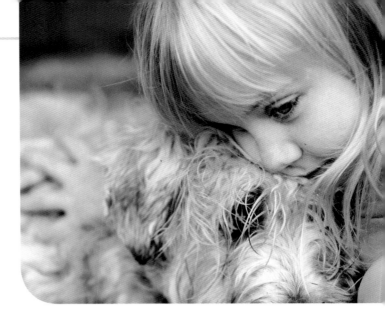

ACKNOWLEDGEMENTS

Many thanks go to all the people involved in helping me to produce this book: David Brockbank, Catherine Connor, Jane Breakell, Carol Poole and my studio team for their constant support; my publisher Angie Patchell and designer Toby Matthews; Brett Harkness and Damien Lovegrove for their amazing technical expertise; Marko Nurminem for his expert photoshop work on all the images; Tamara Peel for her cover photo, my daughter Polly Williams for her "behind the scenes" shots and Karen Fundell for her unique make-up and styling skills; all my wonderful clients and friends, who were happy for me to show you their images; all my seminar "models" and Enza De Luca for finding such beautiful people!

And finally thank you to all the photographers I've met since Contemporary Photographic Training was launched, who continue to be such a wonderful source of inspiration and motivation and allow me to learn as much from them as they do from me!

A FINAL WORD …

I hope you enjoyed reading this book as much as I enjoyed writing it and that it will inspire and motivate you to take pictures without being encumbered by equipment! As you may have worked out for yourselves, I am very passionate about photography and also about inspiring other people to see the easier side of what is often portrayed as so difficult and technical! If you would like to experience a very different way of learning photography, or feel ready to embark on a career as a photographer, please go to www.annabelwilliams.com for details of our training courses and how to join our growing network of like minded people who all have one goal in common: to enjoy taking pictures and constantly be inspired and motivated!

Email studio@annabelwilliams.com to learn how to become a worldwide member of Aspire; the place to meet people like YOU!